Francis Frith's
Pembrokeshire

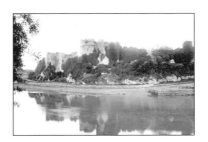

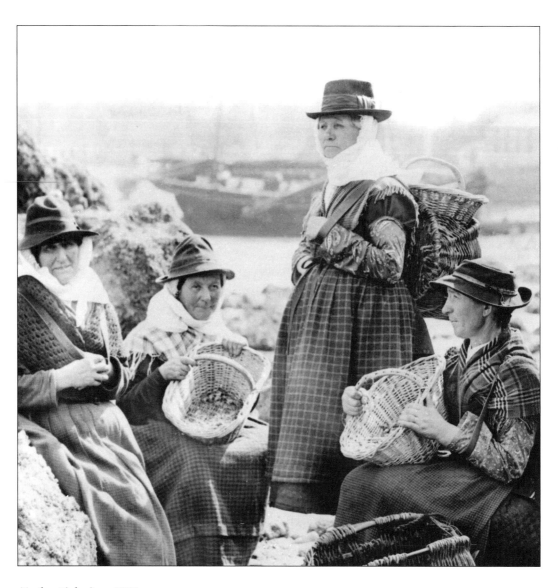

Tenby, Fishwives 1890 28093

Photographic Memories

Francis Frith's
Pembrokeshire

Tony Cornish

First published in the United Kingdom in 2001 by
Frith Book Company Ltd

Hardback Edition 2001
ISBN 1-85937-262-7

British Library Cataloguing in Publication Data

Francis Frith's Pembrokeshire
Tony Cornish

Frith Book Company Ltd
Frith's Barn, Teffont,
Salisbury, Wiltshire SP3 5QP
Tel: +44 (0) 1722 716 376
Email: info@francisfrith.co.uk
www.francisfrith.co.uk

Printed and bound in Great Britain

Front Cover: Pembroke, the Castle 1890 27957

AS WITH ANY HISTORICAL DATABASE THE FRITH ARCHIVE IS CONSTANTLY BEING CORRECTED AND IMPROVED
AND THE PUBLISHERS WOULD WELCOME INFORMATION ON OMISSIONS OR INACCURACIES

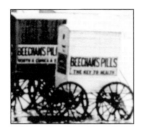

Contents

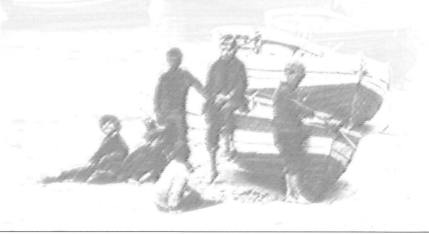

Francis Frith: *Victorian Pioneer*

FRANCIS FRITH, Victorian founder of the world-famous photographic archive, was a complex and multi-talented man. A devout Quaker and a highly successful Victorian businessman, he was both philosophic by nature and pioneering in outlook.

By 1855 Francis Frith had already established a wholesale grocery business in Liverpool, and sold it for the astonishing sum of £200,000, which is the equivalent today of over £15,000,000. Now a multi-millionaire, he was able to indulge his passion for travel. As a child he had pored over travel books written by early explorers, and his fancy and imagination had been stirred by family holidays to the sublime mountain regions of Wales and Scotland. 'What a land of spirit-stirring and enriching scenes and places!' he had written. He was to return to these scenes of grandeur in later years to 'recapture the thousands of vivid and tender memories', but with a different purpose. Now in his thirties, and captivated by the new science of photography, Frith set out on a series of pioneering journeys to the Nile regions that occupied him from 1856 until 1860.

Intrigue and Adventure

He took with him on his travels a specially-designed wicker carriage that acted as both dark-room and sleeping chamber. These far-flung journeys were packed with intrigue and adventure. In his life story, written when he was sixty-three, Frith tells of being held captive by bandits, and of fighting 'an awful midnight battle to the very point of surrender with a deadly pack of hungry, wild dogs'. Sporting flowing Arab costume, Frith arrived at Akaba by camel seventy years before Lawrence, where he encountered 'desert princes and rival sheikhs, blazing with jewel-hilted swords'.

During these extraordinary adventures he was assiduously exploring the desert regions bordering the Nile and patiently recording the antiquities and peoples with his camera. He was the first photographer to venture beyond the sixth cataract. Africa was still the mysterious 'Dark Continent', and Stanley and Livingstone's historic meeting was a decade into the future. The conditions for picture taking confound belief. He laboured for hours in his wicker dark-room in the sweltering heat of the desert, while the volatile chemicals fizzed dangerously in their trays. Often he was forced to work in remote tombs and caves where conditions were cooler. Back in London he exhibited his photographs and was 'rapturously cheered' by members of the Royal Society. His reputation as a

photographer was made overnight. An eminent modern historian has likened their impact on the population of the time to that on our own generation of the first photographs taken on the surface of the moon.

Venture of a Life-Time

Characteristically, Frith quickly spotted the opportunity to create a new business as a specialist publisher of photographs. He lived in an era of immense and sometimes violent change. For the poor in the early part of Victoria's reign work was a drudge and the hours long, and people had precious little free time to enjoy themselves. Most had no transport other than a cart or gig at their disposal, and had not travelled far beyond the boundaries of their own town or village. However,

by the 1870s, the railways had threaded their way across the country, and Bank Holidays and half-day Saturdays had been made obligatory by Act of Parliament. All of a sudden the ordinary working man and his family were able to enjoy days out and see a little more of the world.

With characteristic business acumen, Francis Frith foresaw that these new tourists would enjoy having souvenirs to commemorate their days out. In 1860 he married Mary Ann Rosling and set out with the intention of photographing every city, town and village in Britain. For the next thirty years he travelled the country by train and by pony and trap, producing fine photographs of seaside resorts and beauty spots that were keenly bought by millions of Victorians. These prints were painstakingly pasted into family albums and pored over during the dark nights of winter, rekindling precious memories of summer excursions.

The Rise of Frith & Co

Frith's studio was soon supplying retail shops all over the country. To meet the demand he gathered about him a small team of photographers, and published the work of independent artist-photographers of the calibre of Roger Fenton and Francis Bedford. In order to gain some understanding of the scale of Frith's business one only has to look at the catalogue issued by Frith & Co in 1886: it runs to some 670 pages, listing not only many thousands of views of the British Isles but also many photographs of most European countries, and China, Japan, the USA and Canada – note the sample page shown above from the hand-written *Frith & Co* ledgers detailing pictures taken. By 1890 Frith had created the greatest specialist photographic publishing company in the world,

Frith's death, a new card measuring 5.5 x 3.5 inches became the standard format, but it was not until 1902 that the divided back came into being, with address and message on one face and a full-size illustration on the other. *Frith & Co* were in the vanguard of postcard development, and Frith's sons Eustace and Cyril continued their father's monumental task, expanding the number of views offered to the public and recording more and more places in Britain, as the coasts and countryside were opened up to mass travel.

Francis Frith died in 1898 at his villa in Cannes, his great project still growing. The archive he created continued in business for another seventy years. By 1970 it contained over a third of a million pictures of 7,000 cities, towns and villages. The massive photographic record Frith has left to us stands as a living monument to a special and very remarkable man.

with over 2,000 outlets – more than the combined number that Boots and W H Smith have today! The picture on the right shows the *Frith & Co* display board at Ingleton in the Yorkshire Dales. Beautifully constructed with mahogany frame and gilt inserts, it could display up to a dozen local scenes.

Postcard Bonanza

The ever-popular holiday postcard we know today took many years to develop. In 1870 the Post Office issued the first plain cards, with a pre-printed stamp on one face. In 1894 they allowed other publishers' cards to be sent through the mail with an attached adhesive halfpenny stamp. Demand grew rapidly, and in 1895 a new size of postcard was permitted called the court card, but there was little room for illustration. In 1899, a year after

Frith's Archive: *A Unique Legacy*

FRANCIS FRITH'S legacy to us today is of immense significance and value, for the magnificent archive of evocative photographs he created provides a unique record of change in 7,000 cities, towns and villages throughout Britain over a century and more. Frith and his fellow studio photographers revisited locations many times down the years to update their views, compiling for us an enthralling and colourful pageant of British life and character.

We tend to think of Frith's sepia views of Britain as nostalgic, for most of us use them to conjure up memories of places in our own lives with which we have family associations. It often makes us forget that to Francis Frith they were records of daily life as it was actually being lived in the cities, towns and villages of his day. The Victorian age was one of great and often bewildering change for ordinary people, and though the pictures evoke an impression of slower times, life was as busy and hectic as it is today.

We are fortunate that Frith was a photographer of the people, dedicated to recording the minutiae of everyday life. For it is this sheer wealth of visual data, the painstaking chronicle of changes in dress, transport, street layouts, buildings, housing, engineering and landscape that captivates us so much today. His remarkable images offer us a powerful link with the past and with the lives of our ancestors.

Today's Technology

Computers have now made it possible for Frith's many thousands of images to be accessed almost instantly. In the Frith archive today, each photograph is carefully 'digitised' then stored on a CD Rom. Frith archivists can locate a single photograph amongst thousands within seconds. Views can be catalogued and sorted under a variety of categories of place and content to the immediate benefit of researchers.

Inexpensive reference prints can be created for them at the touch of a mouse button, and a wide range of books and other printed materials assembled and published for a wider, more general readership - in the next twelve months over a hundred Frith local history titles will be published! The day-to-day workings of the archive are very different from how they were in Francis Frith's time: imagine the herculean task of sorting through eleven tons of glass negatives as Frith had to do to locate a particular sequence of pictures! Yet

THE FRANCIS FRITH COLLECTION

Photographic publishers since 1860

| HOME | PHOTO SEARCH | BOOKS | PORTFOLIO | GALLERY | MY CART |
| Products | History | Other Collections | Contact us | Help? |

your town,
your village

365,000 photographs of 7,000 towns and villages, taken between 1860 & 1970.

The Frith Archive
The Frith Archive is the remarkable legacy of its energetic and visionary founder. Today, the Frith archive is the only nationally important archive of its kind still in private ownership.

The Collection is world-renowned for the extraordinary quality of its images.

The Gallery
This month The Frith Gallery features images from "Frith's Egypt".

News...
Image update complete.
An additional 5,000 images have been added and the quality of all images has now been improved.

Sample Chapters avaliable.
The first selection of sample chapters from the Frith Book Co.'s extensive range is now available. All are offered in Pdf format for easy downloading and viewing.

explore
FRITH
Search thousands of photographs from one of the worlds' great archives.

Town search
[GO]

County search
Select a county
[GO]

the FRITHgallery

See Frith at www.francisfrith.co.uk

the archive still prides itself on maintaining the same high standards of excellence laid down by Francis Frith, including the painstaking cataloguing and indexing of every view.

It is curious to reflect on how the internet now allows researchers in America and elsewhere greater instant access to the archive than Frith himself ever enjoyed. Many thousands of individual views can be called up on screen within seconds on one of the Frith internet sites, enabling people living continents away to revisit the streets of their ancestral home town, or view places in Britain where they have enjoyed holidays. Many overseas researchers welcome the chance to view special theme selections, such as transport, sports, costume and ancient monuments.

We are certain that Francis Frith would have heartily approved of these modern developments in imaging techniques, for he himself was always working at the very limits of Victorian photographic technology.

The Value of the Archive Today

Because of the benefits brought by the computer, Frith's images are increasingly studied by social historians, by researchers into genealogy and ancestory, by architects, town planners, and by teachers and schoolchildren involved in local history projects.

In addition, the archive offers every one of us an opportunity to examine the places where we and our families have lived and worked down the years. Highly successful in Frith's own era, the archive is now, a century and more on, entering a new phase of popularity.

The Past in Tune with the Future

Historians consider the Francis Frith Collection to be of prime national importance. It is the only archive of its kind remaining in private ownership and has been valued at a million pounds. However, this figure is now rapidly increasing as digital technology enables more and more people around the world to enjoy its benefits.

Francis Frith's archive is now housed in an historic timber barn in the beautiful village of Teffont in Wiltshire. Its founder would not recognize the archive office as it is today. In place of the many thousands of dusty boxes containing glass plate negatives and an all-pervading odour of photographic chemicals, there are now ranks of computer screens. He would be amazed to watch his images travelling round the world at unimaginable speeds through network and internet lines.

The archive's future is both bright and exciting. Francis Frith, with his unshakeable belief in making photographs available to the greatest number of people, would undoubtedly approve of what is being done today with his lifetime's work. His photographs, depicting our shared past, are now bringing pleasure and enlightenment to millions around the world a century and more after his death.

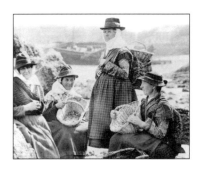

Pembrokeshire - *An Introduction*

PEMBROKESHIRE IS A startlingly beautiful, dramatic, enigmatic county, steeped in history. It has often been referred to as the 'Little England Beyond Wales'. This term, although interesting historically and descriptive of the 'Englishry' south of the fortified 'Landsker' established by the Norman invaders, ignores the Pembrokeshire north of the line; the 'Welshry'. It is this peculiar concoction of languages and cultures that now exist, which perhaps gives the county its unique flavour.

It is true that Norman advances in the years after the Conquest did their best to overturn the previous centuries. Norman saints replaced the Welsh ones, architecture received a new stamp, and bloody war between the Welsh and the Normans was commonplace. The Norman incursions were yet another ingredient poured into this linguistic and cultural melting pot. It is important not to forget that, before any Norman set foot on English soil at Pevensey, Welsh civilisation, its language, its brand of Christianity and tribal military may have held sway here.

The original population of hunter-gatherers was first blended with the Bronze Age settlers from Holland and the Rhine. It was from the county's Preseli Hills that the massive 'bluestones' were quarried, and transported to their resting place at Stonehenge - these were hardly savage, incapable,

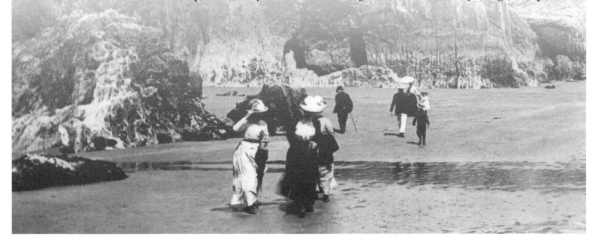

isolationist folk. They traded with Ireland and were sophisticated enough to achieve the remarkable feat of engineering that the quarrying and relocation of the bluestones required.

They in turn coalesced with the Celtic immigrants from continental Europe, the heralds of the Iron Age. They were accomplished builders of hill forts, as is amply demonstrated by such places as Castell Henllys. They also brought with them the proto-Celtic language, the Brythonic building blocks of modern Welsh. Warlike people, they chose the locations of their settlements well, and many of these hill forts became the locations for subsequent Norman fortifications and settlements.

Then came the Romans, and with them a period of comparative peace. The Romans were seemingly content to populate the lush valleys, and leave their Celtic neighbours to their hill-top redoubts. The Romans named this part of their domain 'Demetae', from which came 'Dyfed'. After them, came the Irish tribe of the Deisi in the 5th century. The Deisi settled here and ruled for several centuries. They are credited with the establishment of Christianity here, earlier than in the rest of Britain. Somewhat less benevolent in their intentions, the Vikings raided this coast between 844 and 1091 AD. Then it was the turn of the Normans, who complicated the already complex mix still further when King Henry I, taking advantage of flooding in lowland Flanders, encouraged the dispossessed Flemmings to settle in the county, and to act as a human barrier to the 'unquiet Welsh'. The Welsh despised the Flemmings, even more than their Norman masters.

It was then the turn of Pembrokeshire to export something of its own to England. Henry Tudor was born in Pembroke Castle on 28 January 1457. In 1485 he returned to begin his successful bid for the throne of England. He retained a great love for Wales and its language.

It is important, in all this talk of Kings, Princes and Saints, to remember that Pembrokeshire is also the home of a strong farming community. Less so now than in days gone by, the sea also played an important role in the lives of Pembrokeshire folk. Fishing was a huge industry, but piracy and smuggling were also commonplace. Now these are mostly gone, except for one recent and very notable recurrence in the Newport/Fishguard area! The mine workings and little ports have also disappeared.

Perhaps the last, and I hope the most benevolent invasion of them all, is today's tourist traffic. Many thousands visit this dramatic coastline, exquisite beaches, lush countryside which has a truly remarkable history.

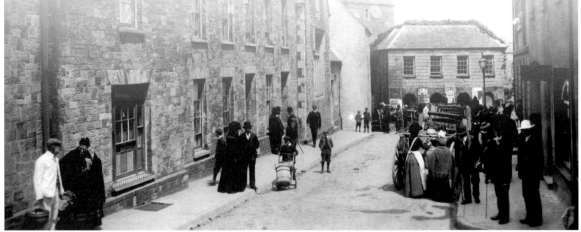

▼ **St Dogmaels, Poppit Sands c1955** S433017

'Llandudoch' in Welsh, St Dogmael's is famous for both its abbey and its coastal views where the Teifi estuary begins to widen out into the sea. This was possibly once the scene of the last Scandanavian raid in Pembrokeshire in 1138, and it is here that the well-known coastal path begins.

▼ **St Dogmaels, River Teifi c1955** S433031

The Teifi was once famous for its fishing of salmon, sewin mullet and 'botcher' by seine net, drawn in after every tide. It was also noted by Giraldus Cambrensis, during the reign of Elizabeth I of England, as being the only river in England and Wales to still have a population of beavers.

"And so running by Cardigan castle and under the bridge [the Teifi river] salutes St Dogmael's as it passes into the sea."
George Owen, 1603

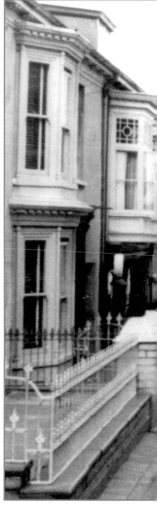

▲ **St Dogmaels High Street c1955**

S433080A

There was once a bustling market here. "...where, by report of ancient men, markets have been kept in old time" (Owen, 1603). Note the interesting brickwork on the house on the right.

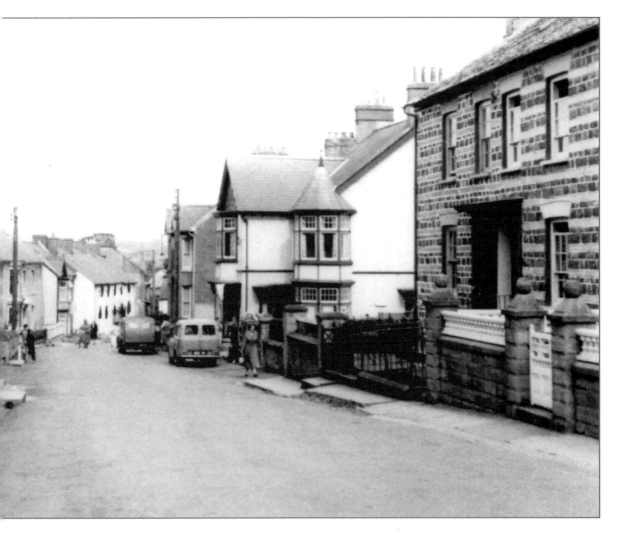

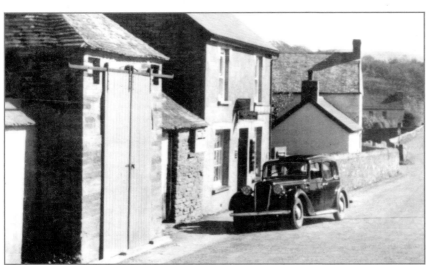

◄ **Nevern**
The Post Office c1955
N116020A
Martin of Tours, or Martin de Turribus, landed in Fishguard in 1087. He married into a prominent Welsh noble family and made Nevern his capital. Nevern was also an important way-station en route to St David's shrine.

"Nevarne is the greatest and largest parishe in the Sheere and taketh the name of the river Nevarne wch runneth well neere throw the myddest of the same."
George Owen, 1603

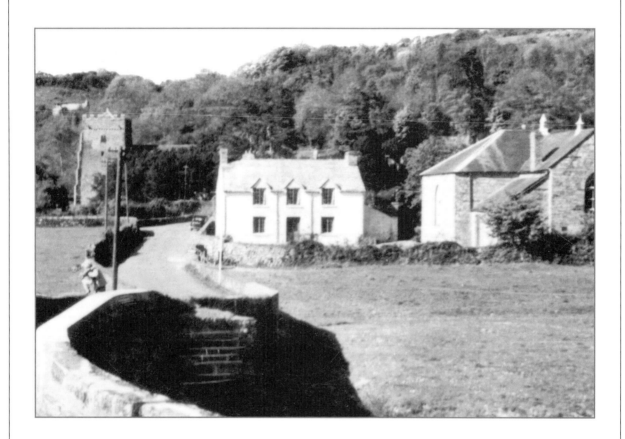

Nevern
Village from the Bridge c1955 N116020B
The church on the left of the picture is dedicated to St. Byrnach whose festival day is
7 April. It boasts a fine 10th or early 11th-century wheel-headed Celtic cross, three
mounting blocks and a 'bleeding' yew tree in its churchyard. Legend has it that an errant
clergyman was hanged from it but not before he ominously prophesied that, he being
innocent of the crime, the tree would forever bleed for him. The tower dates from the
12th century and the rest is late perpendicular. It was restored in 1864 and again in 1952.

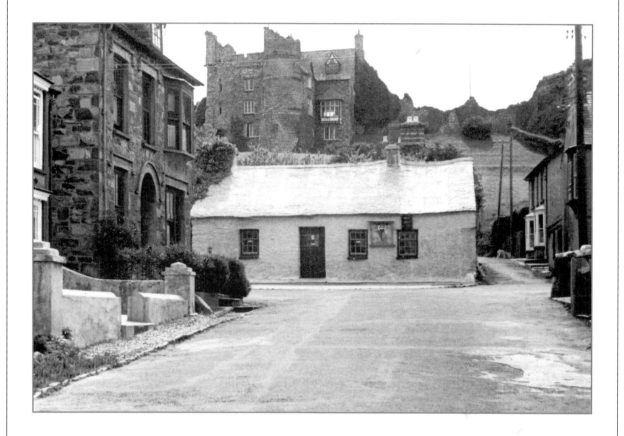

Newport
The Castle c1955 N119039
In a prominent position overlooking the town, the Castle was founded c1200 by William Fitz Martin (a descendant of the Nevern Martin de Turribus), after he was ejected by the Welsh from his original stronghold of Nevern Castle. The town of Newport was sacked and largely destroyed in 1215 by Llewelyn ab Iorwerth and again in 1257. This led the Martin family to rebuild the Castle in stone from c1280-1300. The Castle gatehouse (shown here) is now a private residence. More of the original structure can be seen to its right. The large white building in the centre no longer exists. This is now the site of a small garden in which stands the Newport Millenium Stone.

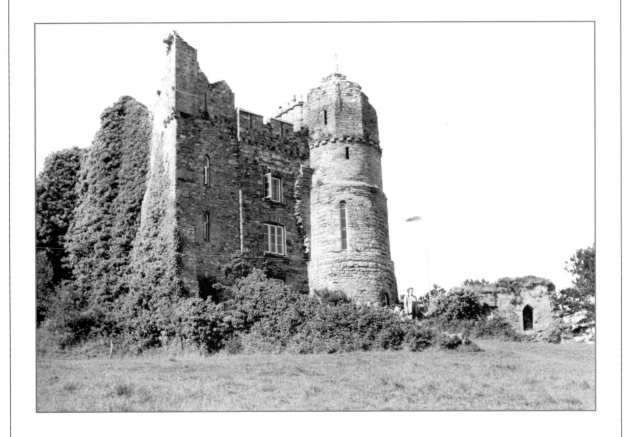

Newport
The Castle c1955 N119053

The Castle and the barony of Cemais passed by marriage into the hands of James de Audley in 1326, after the last male of the Martin clan drowned in the moat of Barnstaple Castle in that year. James Trouchet, Lord Audley, had equally bad luck and was executed for treason on 24 June 1497 for his part in the insurrection led by Perkin Warbeck. He 'was drawn from Newgate to the Tower Hill in a coat of his own arms painted on paper, reversed and torn, and there beheaded'. The ownership then reverted to the Crown but the family were apparently soon back in favour as Henry VII restored the title to James' son. It was sold to William Owen of Henllys in 1543, and it was his son, George Owen, who described it thus as:
"... a strong and lardge castle, moted, garetted, and with towres, and having a lardge court within."
Note the Welsh flag fluttering proudly to the right of the tower.

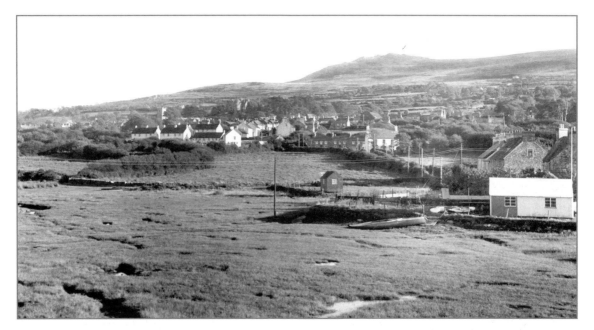

Newport, Carningli c1960 N119075
The St Byrnach of Nevern, who built the first church here, is said to have had his first hermitage on Carn Ingli where he communed with angels who supplied all his needs. It is isolated from the rest of the Preseli range by the Cwm Gwaun (Gwaun Valley), and its name derives from 'Carn Engyl Lle' - the place of angels. The Castle is just visible in the centre of the picture. The marshland is part of the Parrog and now houses a thriving caravan park.

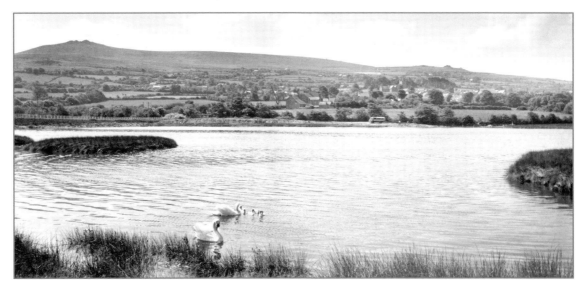

Newport, The Nature Reserve c1955 N119155
The Welsh for this most singular Pembrokeshire town is 'Trefdraeth', the 'township on the sand'. Pictured here is the area upstream of the road bridge, now a nature reserve. Trefdraeth was once a port rivalling Fishguard in significance, but a plague during the reign of Elizabeth I of England was one factor which checked its economic development, as was the development of up-and-coming ports further south. Carn Ingli is prominent on the horizon, the church of St Mary's centre right. Thirty-three dolerite stones were extracted from the Preseli range for the construction of Stonehenge. Seine nets were in common use between the bridge and the sea, but the practice was stopped here and in Nevern in 1958.

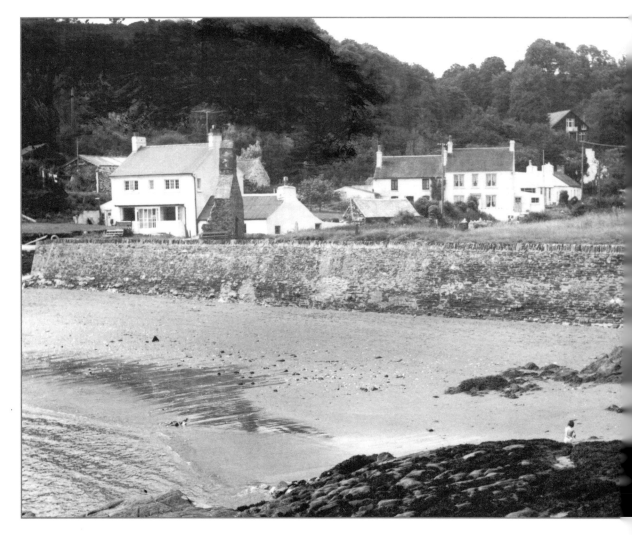

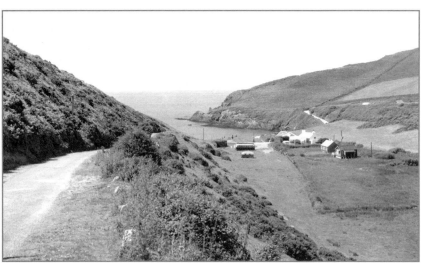

◄ **Dinas, Pwllgwaelod c1960** D228027
Dinas Island was once known as 'Ynys Fach Llffan Gaw' - Little Island of Llyffan the Giant. Situated on the opposite side of the 'island', this village is famed both for its population of grey seals and for being a smugglers' den.

Dinas, Cwm-yr-Eglwys c1960 D228050
On the southern edge of Dinas Island, this tiny seaport once boasted a chapel ('Eglwys' is Welsh for church), the remains of which can be seen here centre left. Only the west wall and bellcote remain after the main part of the structure was destroyed in the great storm of October 1859, which also claimed 113 ships off the Welsh coast.

Fishguard Dinas Head c1960
F28106
This spectacular picture of Dinas Head is taken somewhere between Dinas and Fishguard. Note the houses perched perilously close to the cliff edge and the fields close to storm-driven, salt-bearing sea-spray - a permanent threat to crops on this precipitous edge of the county.

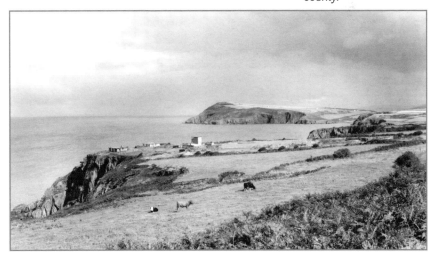

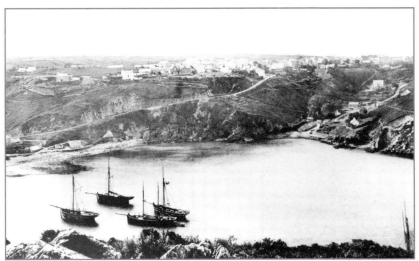

Fishguard Fishguard Bay 1890 27927
Called 'Abergwaun' (mouth of the Gwaun) in Welsh, Fishguard sits astride the Gwaun River where it empties into Fishguard Bay. 'Fishguard' derives from the Scandanavian descriptive name for 'fish-yard'. Limestone, culm (coal dust), timber and contraband were brought in here, and dairy produce, grain and fish exported. The warehouse seen to the left of the picture was latterly HMS Skirmisher, a Royal Navy sail training school. A cluster of fishing boats can be seen in the foreground.

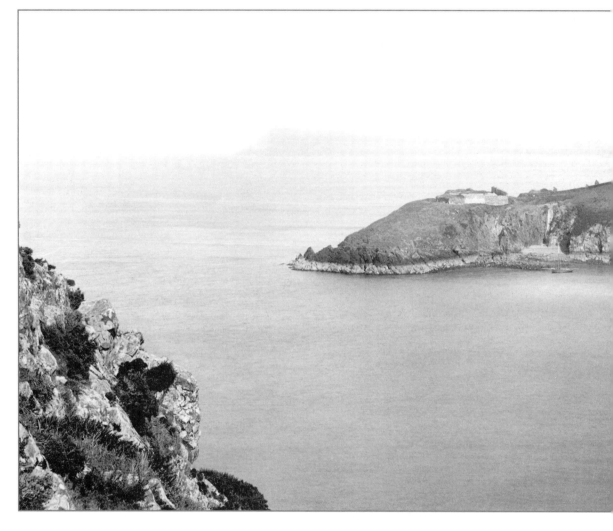

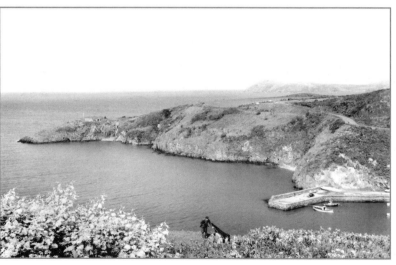

◀ **Fishguard
Old Fort c1960** F28114
This photograph reveals another view of Castle Point with its 1781 fort. In the foreground a gentleman is inspecting what one assumes is an unloaded signal cannon. Fishguard played an important role in the abortive 'Last Invasion of Britain' in 1797, when a French invasion force, hoping to spark a widespread 'peasants revolt', landed nearby. One of the French ships attempted to enter Fishguard, but was seen off with a single cannon shot. The 'Fishguard Fencibles' were one of the local militias called out to defeat the invasion.

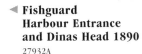

**◀ Fishguard
Harbour Entrance
and Dinas Head 1890**

27932A

The old fort seen on the headland of Castle Point was completed in 1781 and boasted eight cannons, each capable of firing a nine or twelve-pound shot. Dinas Head can be seen in the distance.

**▼ Fishguard
Lower Town c1955**

F28043

Dylan Thomas's classic 'Under Milk Wood', starring Richard Burton and Elizabeth Taylor, was filmed here in Fishguard Lower Town.

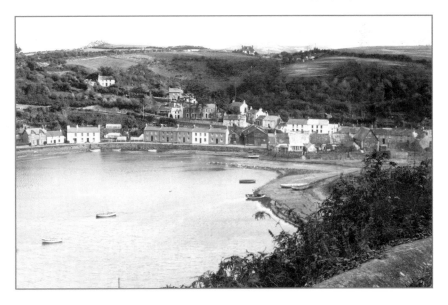

**◀ Fishguard
Gwaun Valley c1955** F28302

Here we see an excellent example of glaciations and a remnant of a bygone age. In 1582 Pope Gregory XIII ordered a change from the Julian to the Gregorian calendar. This was finally implemented in Britain in 1752, whereupon the 2nd September was, somewhat abruptly, followed by the 14th. However, this alteration was not observed in the Gwaun Valley - for many years they refused to change and continued to celebrate New Year on January 13th!

In the so-called 'Last Invasion of Britain' of 1797, a local heroine, one Jemima Nicholas (or 'Jemima Fawr') - Big Jemimah - apparently single-handedly rounded up twelve of the French invaders with the aid of a pitchfork, herded them to the town jail and then returned for more. For this courageous deed "she was rewarded by the inhabitants with as much ale as she could drink, and that not a little". She was a tall, stout, powerful, almost Amazonian character, a cobbler by trade, and "altogether the most masculine my eyes ever beheld!" Her gravestone reads: "The Welsh Heroine who boldly marched to meet the French Invaders who landed on our shores in February 1797." She died aged 82, having been rewarded with a £50 per year pension for her gallantry.

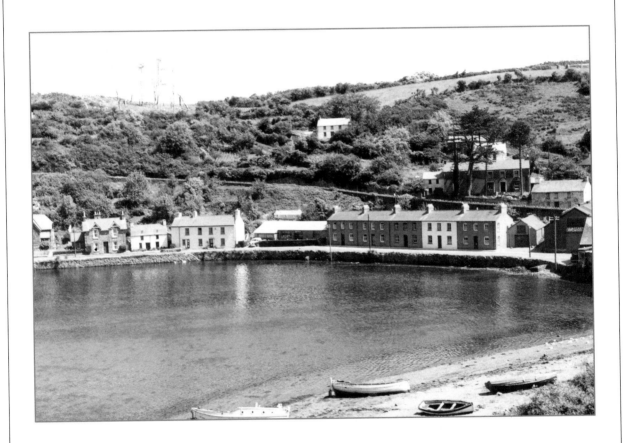

Fishguard
Harbour c1960 F28085
Now much more developed, the Lower Town is still well worth a visit.
The multi-coloured cottage frontages make an enchanting and enduring
picture. Note the beached boats in the lower half of the picture.

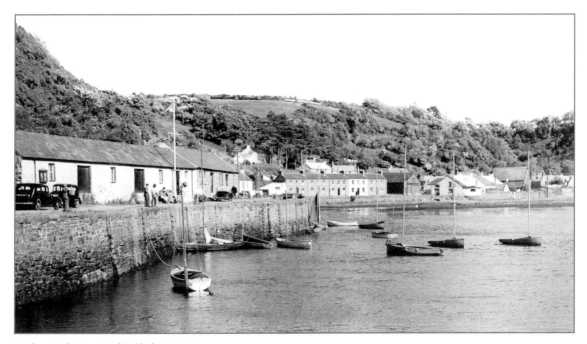

Fishguard, Bay Yacht Club c1955 F28318
This excellent view of the harbour, 'Y Cwm', shows the row of warehouses along the harbour wall on the left. The Pier, from which I think this photograph was taken, was built by Samuel Fenton.

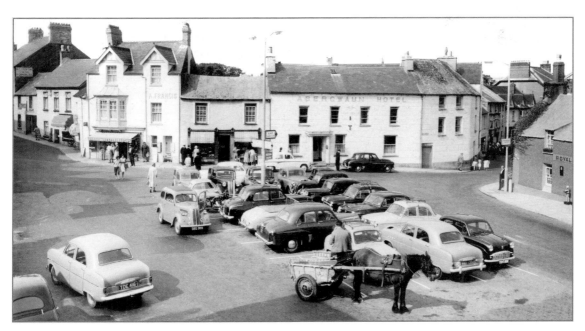

Fishguard, The Square c1960 F28100
This is not so much of a square as a roundabout these days. There is no car parking today, but a busy road junction with a cannon in the centre. Note the A. Francis shop centre(ish) and W.R. Eynon & Sons, General Ironmongers on the left. The Abergwaun Hotel still trades. The Royal Oak, part of which can be seen on the right has the claim to fame of reputedly being the place in which the official surrender of the invasion was signed on 22 February 1797. Note the rubber-tyred horse-drawn cart in the foreground.

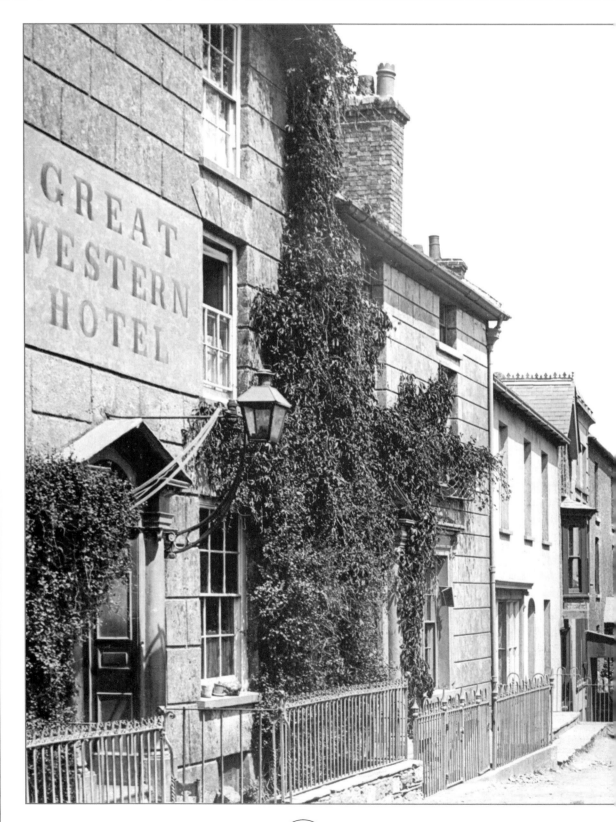

**Fishguard
Town Centre 1899**
43641
This view shows the higher part of the town. Note the Rees, Baker & Co., Fishguard delivery cart and the Great Western Hotel on the left. In the pre-railway days coaches left from this hotel to connect with the railway at Haverfordwest — a two-and-a-quarter-hour journey.

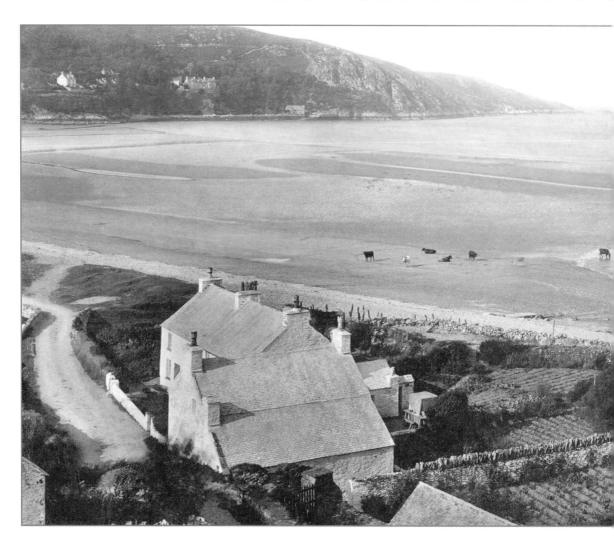

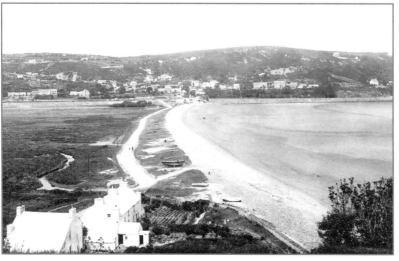

Goodwick, Village 1899 43642
In pre-ferry days, Goodwick was simply a small fishing village. It was on the sands here that the French invasion army laid down its arms — with the exception of 25 who could not attend due to temporary incapacity (they were ill or probably drunk on looted wine). The total casualties were 8 French drowned, 12 French killed and one Welshwoman killed in a pub when a pistol was accidentally discharged. Note the boats pulled up above the high-water mark, the free-range livestock grazing, and the vegetable plot by the cottage.

◄ **Goodwick , The Sands 1890** 27933
This photograph was taken in pre-breakwater days; Goodwick is now the port from which the Irish ferry service operates. As well as the quay there is also a railway terminus. The breakwaters seen today were built in 1906. Cattle can be seen resting on the beach.

▼ **Goodwick, The Harbour c1955** F28002
The Great Western Railway (GWR) steamers seen alongside the harbour have now been replaced by the Irish ferries operating from Goodwick. Warehouses can be seen centre and on the right. During the American War of Independence, an American privateer under the command of either Stephen Manhant or the (in)famous Paul Jones in his *Black Prince*, seized a ship belonging to Samuel Fenton, and landed a raiding party. He threatened to bombard the town unless a ransom of 500 guineas for the ship and 500 guineas for the town were paid over. It is uncertain whether the ransoms were in fact paid, but the *Black Prince* fired broadsides into the town before the raiders were eventually seen off. Note the railway carriages behind the steamers.

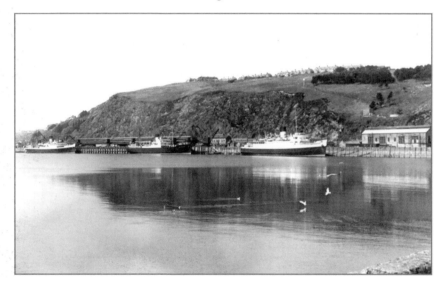

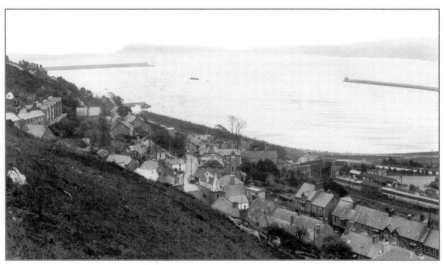

◄ **Goodwick, Harbour c1955** G171003
The breakwaters are now in plain view. The rock for these was blasted out of the cliff, 800 tons being required for each linear foot! The scheme for this was initiated in 1846 but was delayed due to the Irish famine. It was restarted in 1846 and finally completed in 1906. Note the railway on the right.

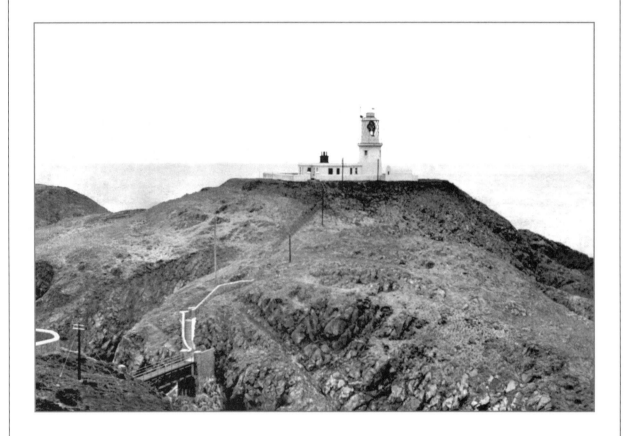

Fishguard
Strumble Head Lighthouse c1960 F28045

This important lighthouse perched on top of this windswept point on the Pen Caer Peninsula is Pembrokeshire's nearest point to Ireland and cost £40,000 to build in 1908. Run by Trinity House, it was automated around 1980, but prior to that was staffed with a two months on, one off, rota. Nearby is Carreg Wastad Point where, in 1797, a French invasion force of 600 troops, 800 ex-convicts, 100 emigrés and three Irish officers led by William Tate, an Irish-American, attempted their farcical 'invasion'. This so-called 'Légion Noir' (due to their uniforms being dyed black) looted nearby farms to discover plentiful stocks of Portuguese wine 'recovered' from a recent wreck ... and set about consuming as much of it as they could. They were subsequently no match even for the local militias who, so the legend has it, were supported by a troop of local Welsh ladies who, in their tall black hats and with red petticoats on show, looked to the Légion Noir (perhaps due to somewhat impaired vision) rather like British troops.

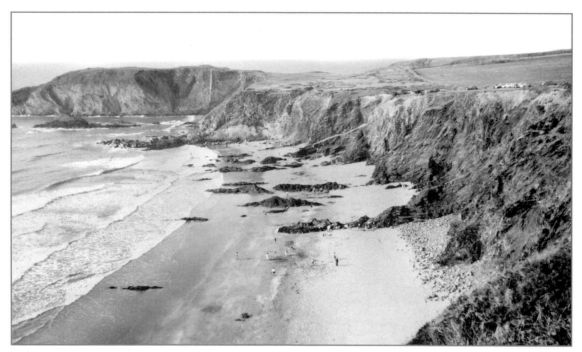

Llanrhian, Traeth Llfyn (Llyfyn Beach) c1960 L267160
Steep cliffs and sandy beaches characterise this beach as they do so many others in the county. Note the people on the beach and the complete absence of beach towels, windbreaks and other paraphernalia.

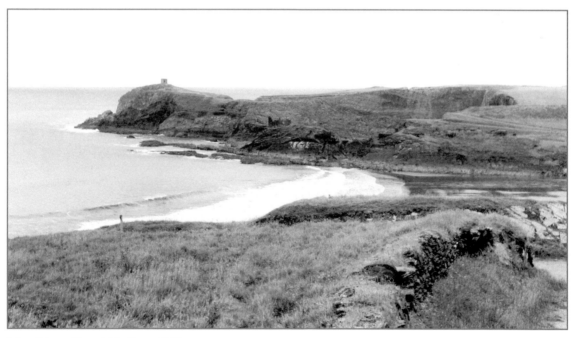

Llanrhian, Abereiddy Bay c1960 L267001
Geese, cattle and sheep all once grazed freely on this isolated shingle shore. Just beyond the first headland is the 'Blue Lagoon', a worked-out and flooded slate quarry which vessels would enter via a narrow channel at high tide. This safe anchorage also boasts an abundance of marine life as well as a wealth of fossils.

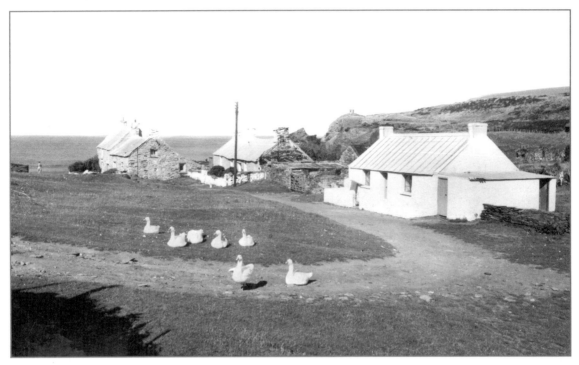

Llanrhian, Abereiddy c1960 L267017
This scene remains much the same today. Note the free-range geese.

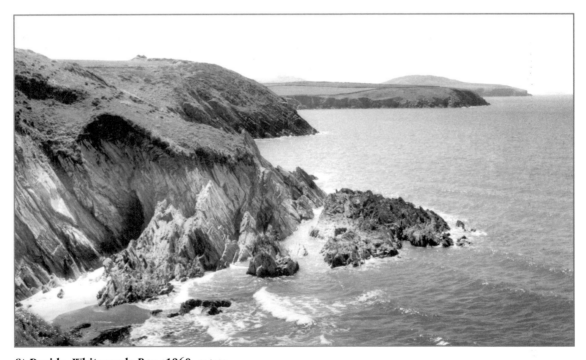

St Davids, Whitesands Bay c1960 S14183
There is a chapel dedicated to St Patrick in the Bay marked by a plaque; he is said to have set out for Ireland from here.

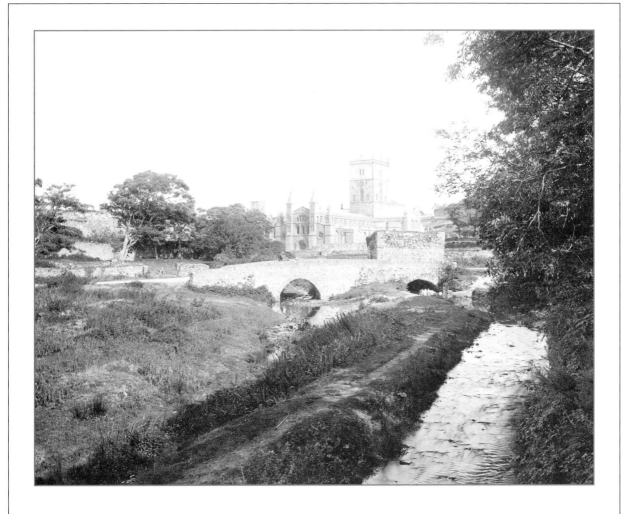

St David's
From the South-West 1890 27908

Technically a city, St David's or Tyddewi (after Dewi Sant, the patron saint of Wales who established his monastery here on the banks of the river Alun), boasts the remains of the impressive Bishop's Palace. The legend has it that David, about to speak to an assembled crowd, was concerned they would not be able to see him. He dropped his handkerchief onto the ground, which sank down, forming a hollow, a natural amphitheatre in which everyone could see and hear him. The Cathedral was built on this spot. The complex, much of which can still be seen today, was once surrounded by a curtain wall - the Norman response to its having been attacked and pillaged at least eight times! Giraldus Cambrensis (a statue of whom can be seen in the Cathedral) had this to say: "St Davids is the head and in times past was the metropolitan city of Wales, though now, alas, keeping more of the name than the effect."

"When the evening sun falls over St Davids Cathedral, gilding the old stone, shining on the gentle green hills, the white twisting roads and the little farms, the smallest 'city' in the kingdom lies lost in its mighty memories. The sea wind drops, the smoke rises upward from the chimneys, and a man looking at the church in the hollow knows it to possess the longest memory in Britain."

H.V. Morton, 1932

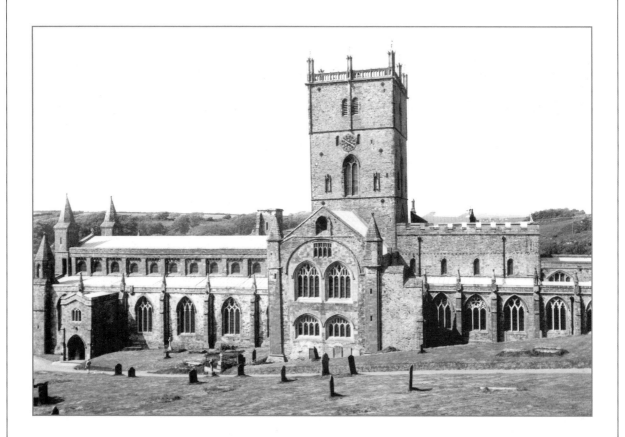

St David's, The Cathedral c1960 S14130
A local legend has it that the wife of a heathen chief Boia told her maids 'to go where the monks can see you with bodies bare, play games and use lewd words', in order to tempt the monks away from their vows. Dewi Sant remained strong, and thereafter he and his monks worked with heads bowed in case they should see more temptations of the world. The same legend also says that Boia and his camp were promptly all destroyed by heavenly fire!

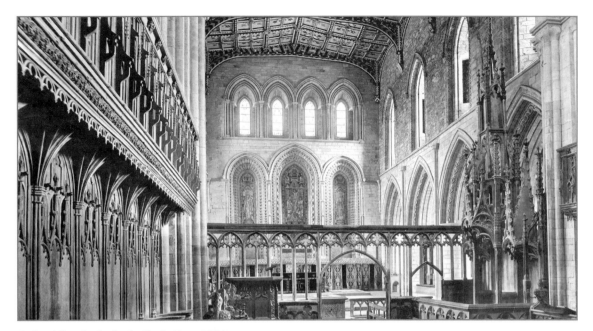

St David's, Cathedral, Choir East 1890 27915
St David's is in a somewhat austere location, on its windswept plateau, but the interior of the Cathedral is simply stunning. The roof beams were renewed in the 19th century. The Bishop's Throne, dating from c1500, is on the right before the open wooden screen, which separates the choir from the presbytery. The tomb beyond the screen is that of Edmund Tudor, the Earl of Richmond.

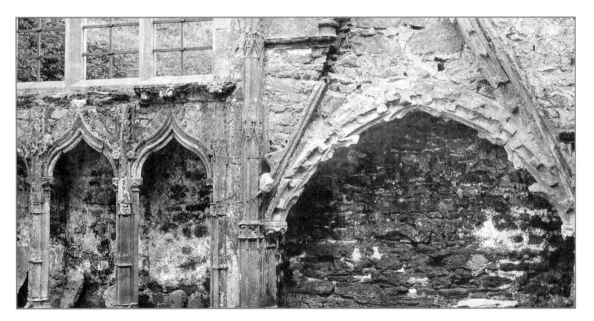

St David's, Cathedral, St Mary's Chapel 1890 27920
This is in the remains of the extensive Bishop's Palace, which is now much restored. The medieval name for St David's was 'Menevia', from the Welsh 'Mynyw' which is itself derived from the Irish 'Muine' meaning a bush. William the Conqueror once journeyed here to pray in this well-known place of pilgrimage.
'Roma semel quantum bis dat Menevia tantum'
Once to Rome is equal to twice to St David's.

▼ **St David's, Cathedral and Bishop's Palace c1960** S14123
The cathedral is seen across the magnificent Bishop's Palace built by Henry Gower. On the right is a wheel window just visible in the east gable. Note also the arcading on the top of the walls.

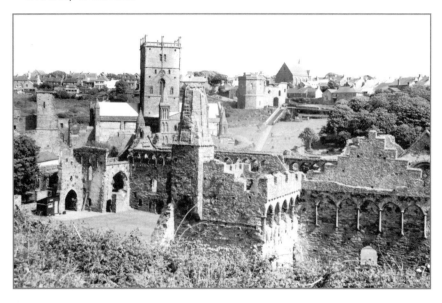

▼ **St David's, Cross Square c1950** S14050
Silver and lead were mined nearby in the reign of Elizabeth I of England (1558-1603). St David died 1 March 588 AD and one writer had this description of the event written in 1346:
"Jesus Christ bore away David's soul in great triumph and gladness and honour. After his hunger, his thirst, and cold, and his labours, his abstinence and his acts of charity, and his weariness, and his tribulation, and his applications, and his anxiety for the world, the angels received his soul, and they bore it to a place where the light does not fail, and there is rest without labour, and joy without sadness, and abundance of all good things, and victory, and brilliance, and beauty..."

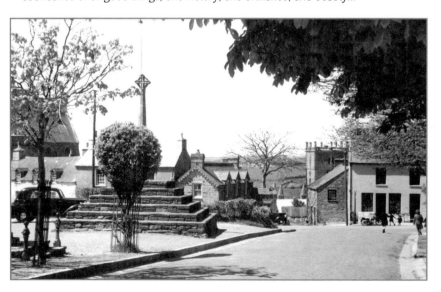

▲ **St David's Caerfai Bay c1960**
S14161
The purple sandstone for the Bishop's Palace was quarried from the cliffs above Caerfai Bay. Life on this peninsula was hard, for the monks as well as the farmers:
"...they place the yoke on their own shoulders; they dig into the ground with mattocks and spades, they provide with their own labour all the necessities of the community."
Life of David, c1090

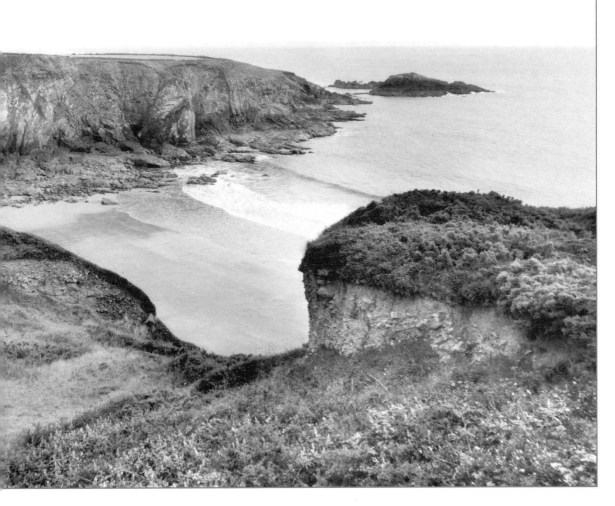

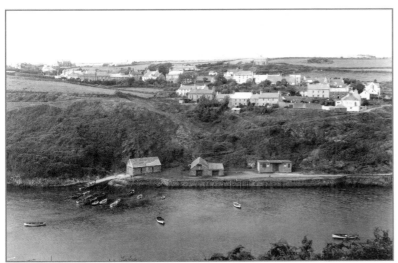

◀ **Solva, From the Gribbin c1955**
S413015

Lower Solva is built around the harbour, but there were also eight lime-kilns here in 1908. The artist Augustus John passed through the area and commented: "Solva proved so pleasant that two or three weeks passed before we took the road to St David's." But the sea can be cruel as well as kind. In 1773 there was a terrible shipwreck nearby of the *Phoebe and Peggy*, a ship bound from Philadelphia to Liverpool. Sixty people were drowned and the cargo lost. Seven fishing boats set out to help but one of these was also lost with all hands when it struck Black Rock.

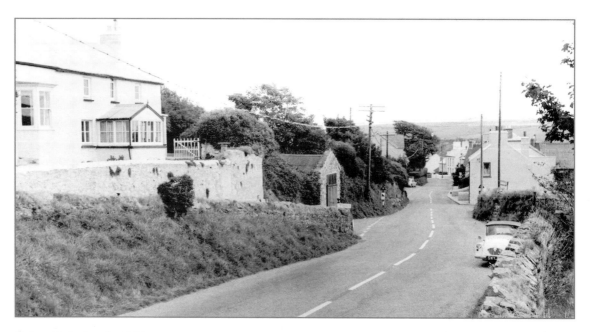

Solva, Main Road c1965 S413083
Solva was something of a wrecker's haven, with many of the old houses having secret cupboards and holes in which goods could be stashed away. Solva "... had the reputation of hanging out false lights to decoy the wandering mariner in order to benefit from his misfortunes" (Richard Fenton, 1811). A signpost is visible saying three miles to St David's and also there is a classic three-wheeler car on the right.

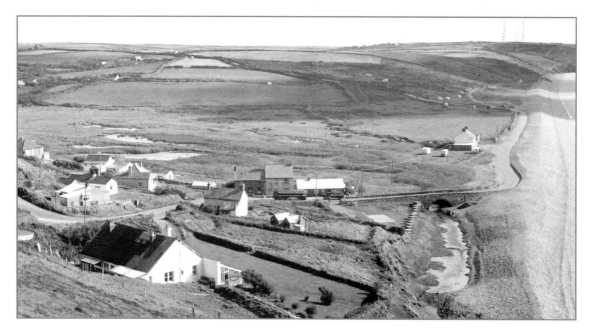

Newgale, The Beach c1960 N64024
This is the longest beach in Pembrokeshire (two miles end to end), lying below a shingle storm ridge. The old road follows the line of the ridge and the beach was once occasionally used to load coal onto boats at high tide from the nearby Trefân Cliff Colliery. In 1690 the *Resolution* was wrecked here and robbed "by the more unmerciful people of the neighbourhood".

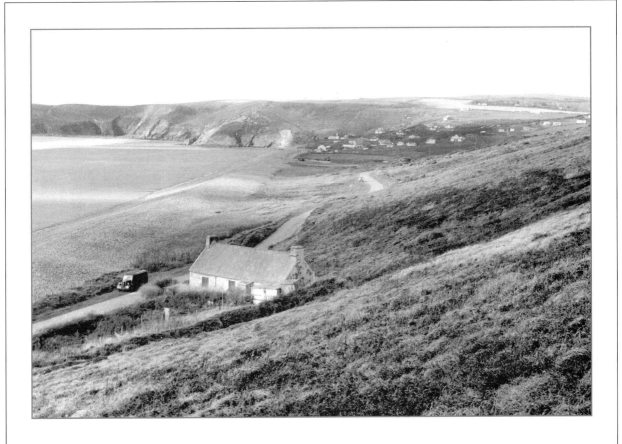

Newgale
The Old Welsh Road 1954 N64025

A change in sea level and erosion have combined to produce a fascinating
effect off this beach, as documented by Giraldus Cambrensis:
"We then passed over Niwegal sands, at which place (during the winter
that King Henry II spent in Ireland), as well as in almost all other western
ports, a very remarkable circumstance occurred. The sandy shores of
South Wales, being laid bare by the extraordinary violence of a storm, the
surface of the earth, which had been covered for many ages, re-appeared,
and discovered the trunks of trees cut off, standing in the very sea itself,
the strokes of the hatchet appearing as if made yesterday."

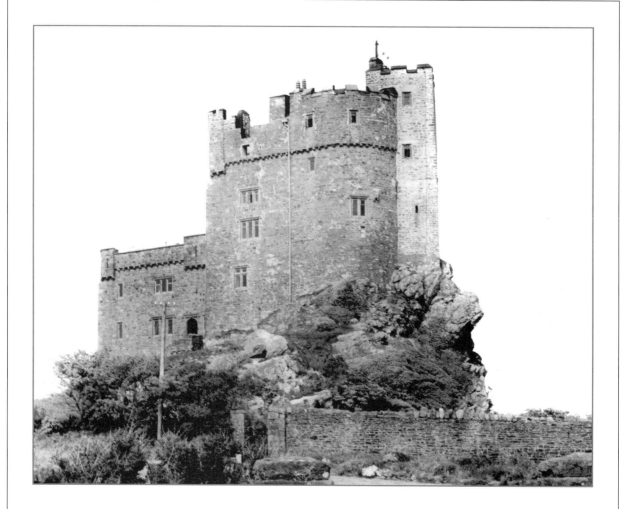

Roch
The Castle c1955 R293014

The castle was built by the de la Roche family in the late 12th/early 13th centuries. It rises up dramatically from a volcanic outcrop. Legend has it that the first owner, Adam de la Roche, was told by a local witch that he would die from the bite of a snake, but if he lived (adder-free) for a year the prophecy would not come to fruition. He ordered the castle to be built on a rocky outcrop to confound the local serpents and confined himself to the tower. All seemed to be going swimmingly right up until the last day of the curse. He was cold and sent for firewood. Unfortunately, the bundle of sticks included an adder, which, of course, bit him and Adam died. This is one of the 'Landsker' castles, which formed an early boundary between the 'Englishry' and the 'Welshry'. The tower would originally have been surrounded by a bailey wall and outside that by a double ditch and bank. During the mid-17th-century Civil Wars it was first held for the King by the Earl of Carberry in 1642, but surrendered to Colonel Rowland Laugharne in the February of 1644. It changed hands again in July of the same year and stayed in the Royalist camp until early 1645. The castle was converted into a private residence in 1902.

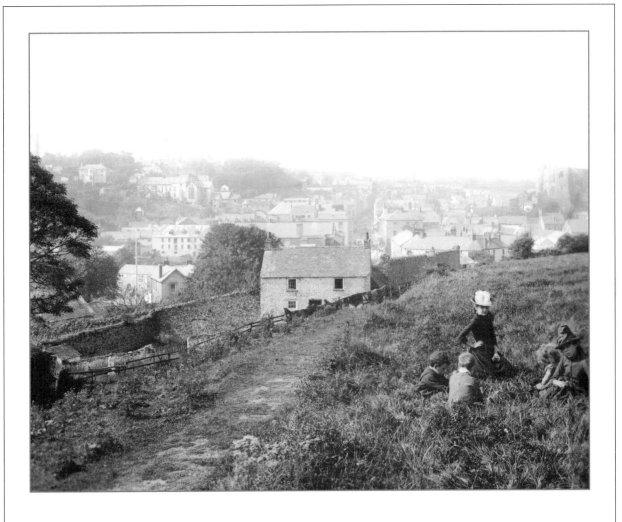

Haverfordwest
General View 1890 27938
The photograph shows a group of turn-of-the-century children
overlooking the town of Haverfordwest. The Castle can be clearly seen
on the right of the picture, as can the tower of St Mary's on the horizon.

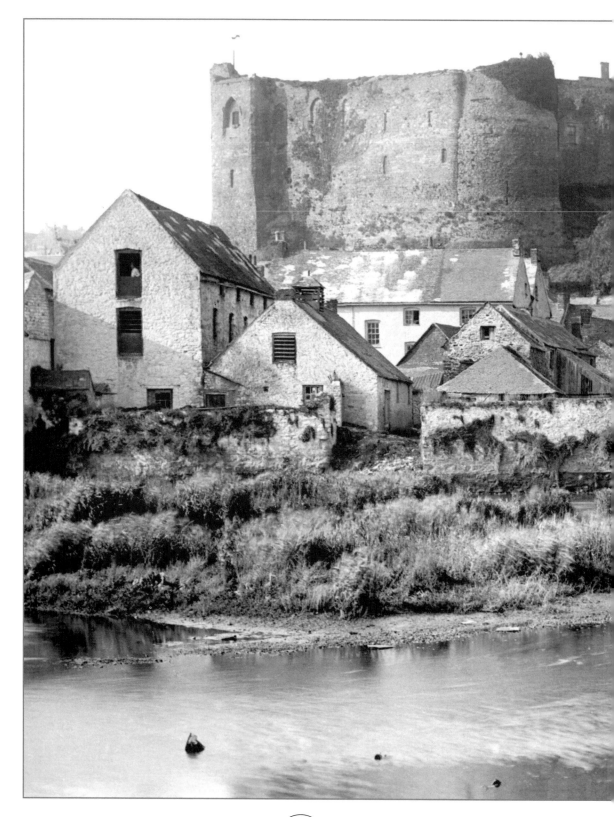

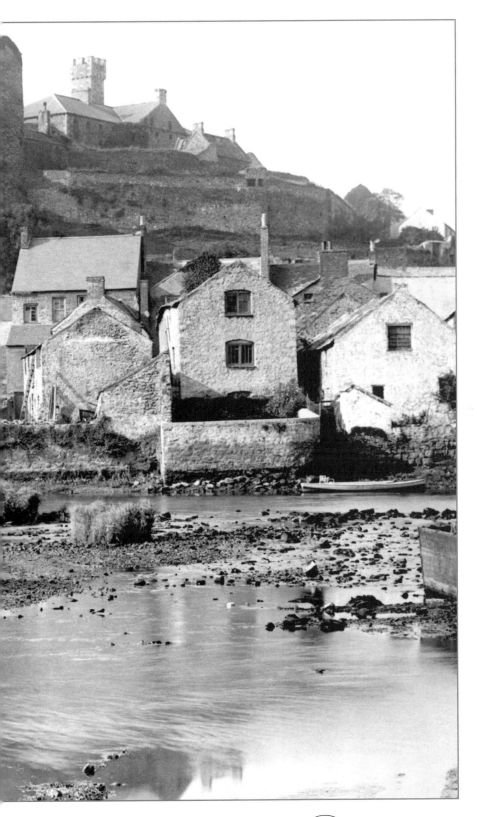

**Haverfordwest
The Castle from the
River 1890** 27940
This is an evocative
view from the north-
east part of the town
below the Castle walls,
showing the impressive
Castle and prison itself.
The watchtower in the
roof of the new prison
was built so that the
guards could observe
all activity in the prison
exercise yards. These
buildings in the shadow
of the Castle walls were
the site of the
Marychurch Foundry,
the town's biggest
employer until its
closure in the mid-
1930s.

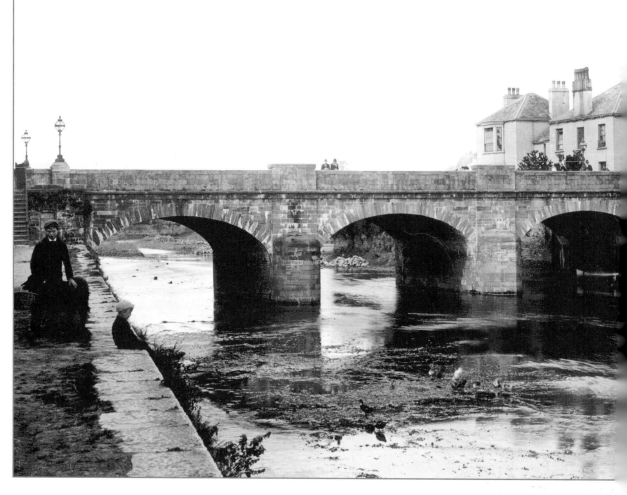

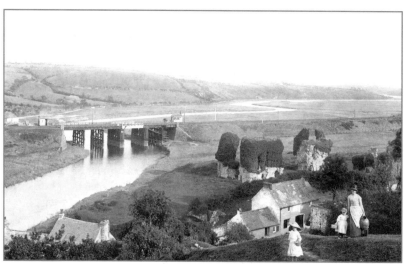

◀ **Haverfordwest**
The Priory Ruins 1890 27951
The Augustinian Priory of St
Mary and St Thomas the Martyr
was founded c1200 by Robert
Fitz Richard (d. 1213). The
three medieval churches of St
Mary's, St Thomas à Becket and
St Martin's were all gifted to the
Priory by Robert, and must have
been a significant source of
income. The Priory was closed
in 1536 at the time of the
Dissolution of the Monasteries.
Note the lady in the right of the
picture carrying the
earthenware jug, and the railway
bridge across the Western
Cleddau.

◄ **Haverfordwest
The New Bridge 1890**
27948
The wall on the left, on which the child is sitting, has since been extensively re-developed as the river frontage for a shopping development. It is now a series of steps leading down to the water. Out of sight, and beyond the bridge to the left is the new County Hall.

▼ **Haverfordwest
Market Street 1898** 41080
This photograph is taken from the junction of Market Street and Upper Market Street, looking down towards the High Street. At the time of writing, the arched building on the left is a building site. The bay windows on the right are still in existence. Note the ladder on the pavement to the right of the picture, the scarcity of traffic, and the complete absence of road markings.

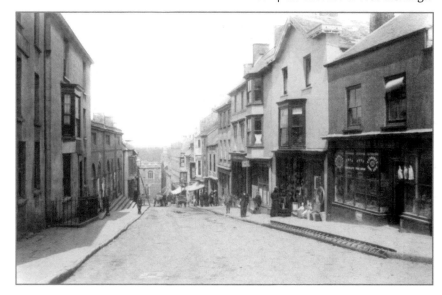

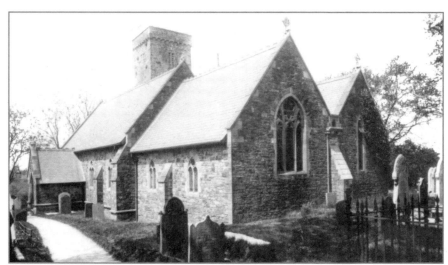

◄ **Haverfordwest
Prendergast Church
1899** 43635
St David's Church, Prendergast, occupies a commanding position. It overlooks the Cleddau River and the town of Haverfordwest. The church was altered in Victorian times, and it serves the outlying village.

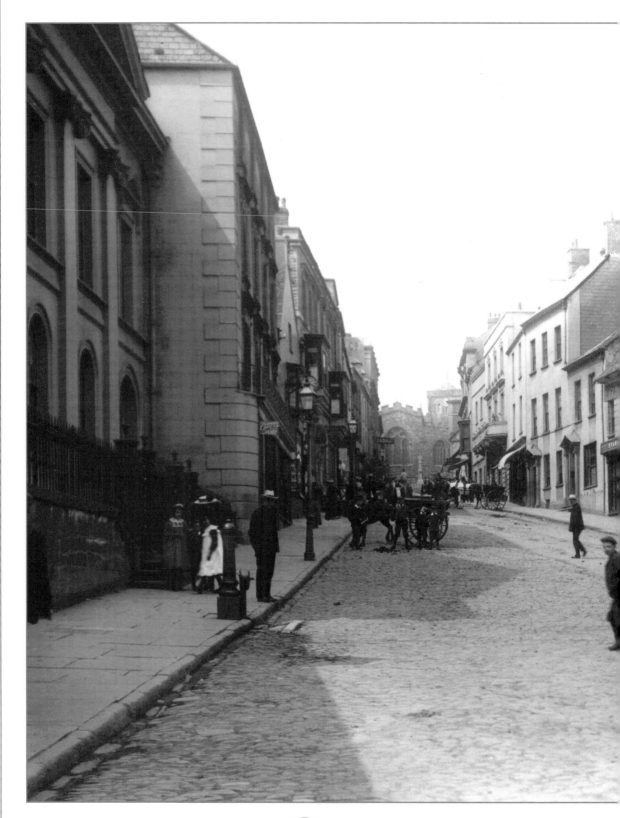

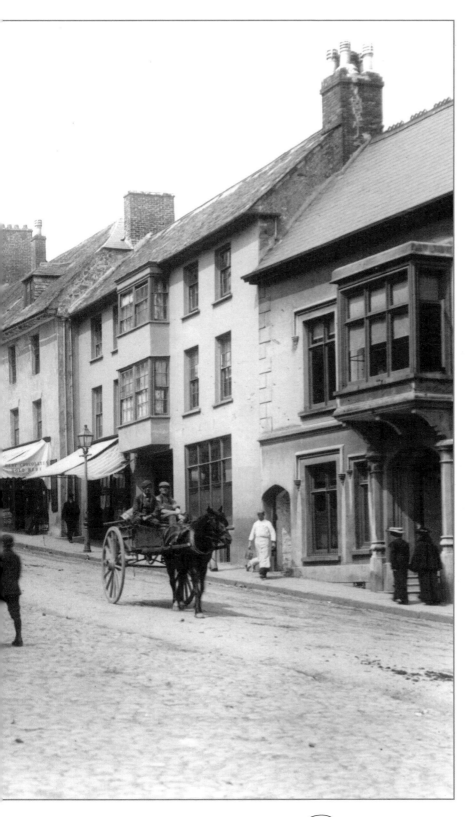

**Haverfordwest
High Street 1906**
53743
The cobbled street has
now been replaced by
conventional tarmac,
however the High Street
in Haverfordwest is
shown well here, with
St Mary's Church at the
end of the street.

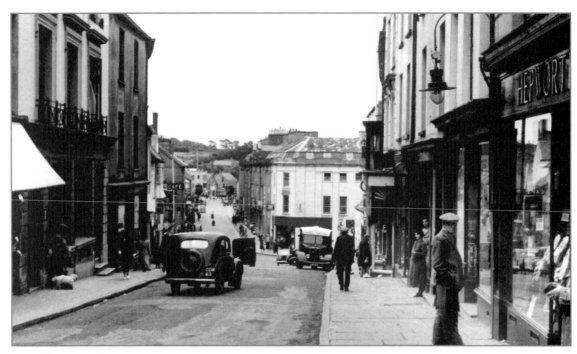

Haverfordwest, High Street c1955 H41020
This photograph looks down the High Street towards Salutation Square. Note the Ever Ready delivery van in the centre of the picture and the branch of Hepworths on the right.

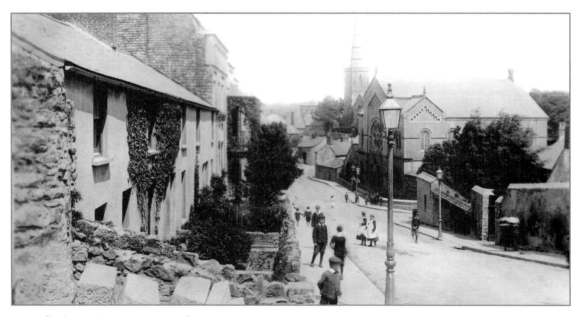

Haverfordwest, Barn Street 1906 53749
This is a view looking down Barn Street towards the spire of St Martin's Church. The Bethesda Baptist Chapel can be seen on the right. This site at the foot of Barn Street was purchased in 1789 for £200, and by September of that year a Chapel costing £308 and 6s was completed. It was rebuilt in 1816, but damaged in a gas explosion in 1842. Work on the present Chapel was completed in 1880 at a cost of £2,199. The elaborate wrought-iron façade on the building on the left is still in existence, and sports a beautiful wisteria. Note the Victorian street lamps.

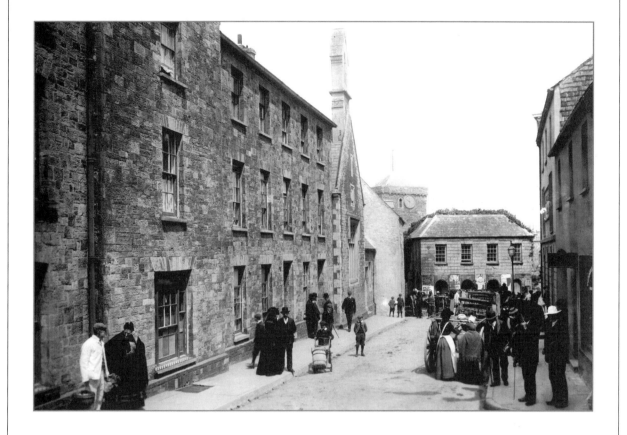

Haverfordwest
Dew Street 1906 53748

The building in the centre of the picture was the former butter and fish market. It dates from 1791, and this two-storey building served this purpose until 1900, when the ground floor became a municipal dairy and the upper storey the repository of the Council records. It was demolished in 1951, and became the site of the 1939-45 War Memorial, until this was moved to Salutation Square. The building on the left was the former grammar school, which was demolished and is now the site of the library. The steeply angled gable end with bellcote beyond the grammar school is that of the Roman Catholic Church of St David and St Patrick, which opened in 1872. The tower of St Mary's Church can been seen beyond the butter and fish market. In the centre of the picture a delivery boy is pushing a barrel on a handcart.

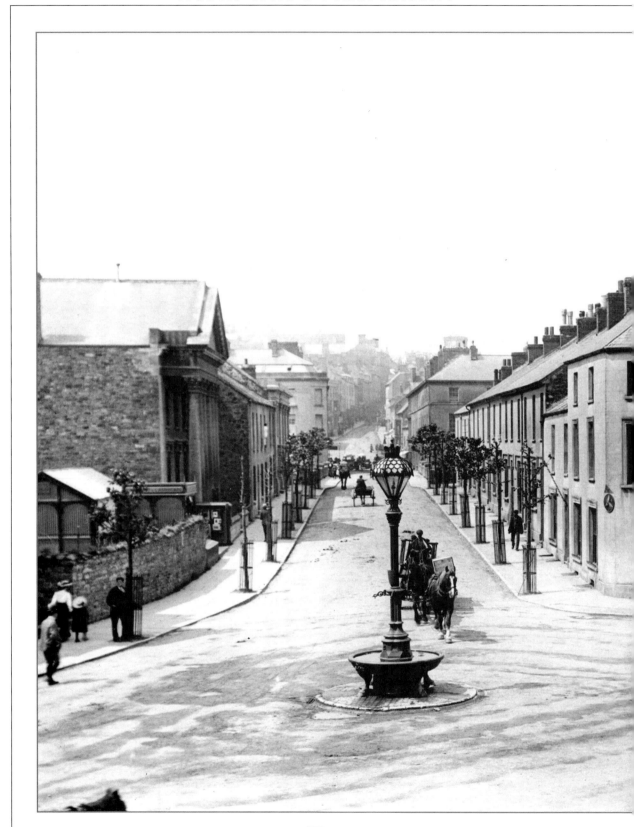

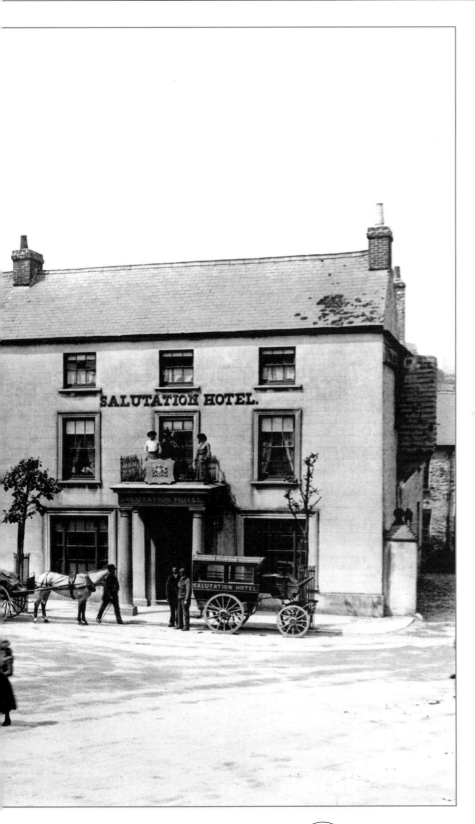

Haverfordwest Salutation Square 1906 53747
This is a charming turn-of-the-century tableau of Salutation Square, which is the main access into the town. Note the hotel carriage by the entrance, the various horse-drawn conveyances and also the people on the hotel balcony. The chapel with the colonnaded frontage is now 'R.J.'s Nitespot'. The girl crossing the square in the centre of the picture would today be counted suicidal as this is now a very busy thoroughfare. The fountain in the middle of the square has now been removed.

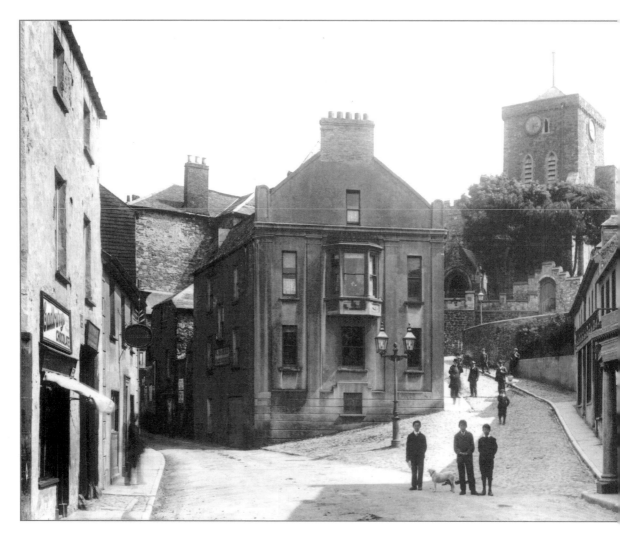

◀ **Broad Haven
The Beach 1898** 41100
On the coast of St
Bride's Bay, this sandy
beach was a fashionable
bathing place in the 19th
century. Star Rock is just
visible below the far
headland.

◄ Haverfordwest
Mariner's Square 1906 53751
In the shadow of St Mary's Church, the Hotel Mariners (on the right) was established in 1625. The building to the centre is now without its bay window. A sign advertising Cadbury's chocolate can be seen on the left, and also the cobbled street leading up to the church. The three boys and their dog in the centre of the picture, and the various people beyond, are obviously captivated by the moment.

▼ Broad Haven
View from the Rocks c1950 B469027
Broad Haven is sheltered from south-westerlies by a range of cliffs and St Govan's Head. It is a popular tourist destination today. People are exploring in the rock pools, centre left. Coal from nearby collieries was occasionally loaded onto boats here.

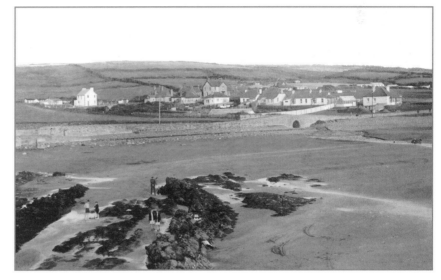

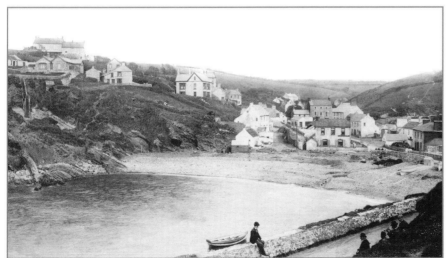

◄ Little Haven
Black Rocks 1898
41100A
This end of a narrow valley at the foot of a steep hill has been a popular seaside resort for many years. It also had nearby coal-pits, which sent out some of their produce from the beach here. On the left are steps leading down to the beach, the Castle Hotel is centre right and a trumpet player is practising front right!

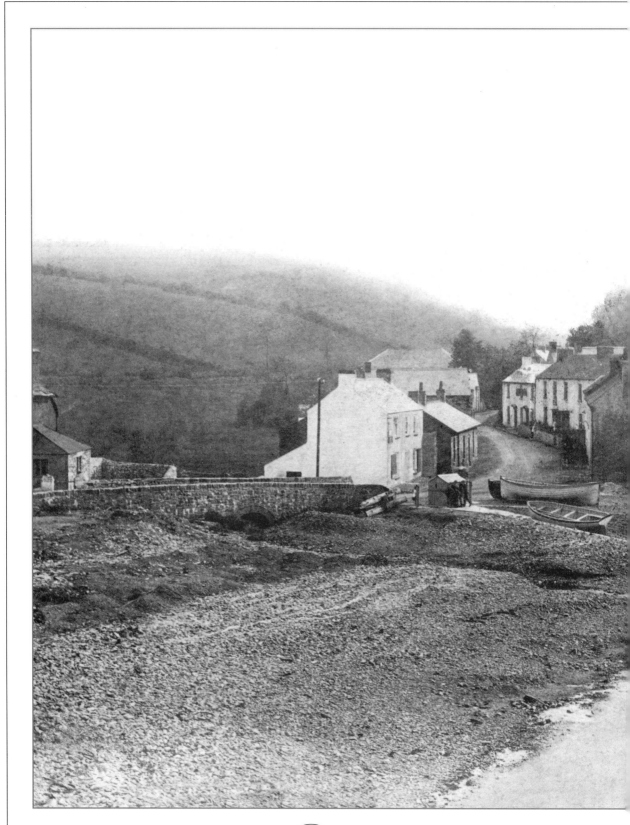

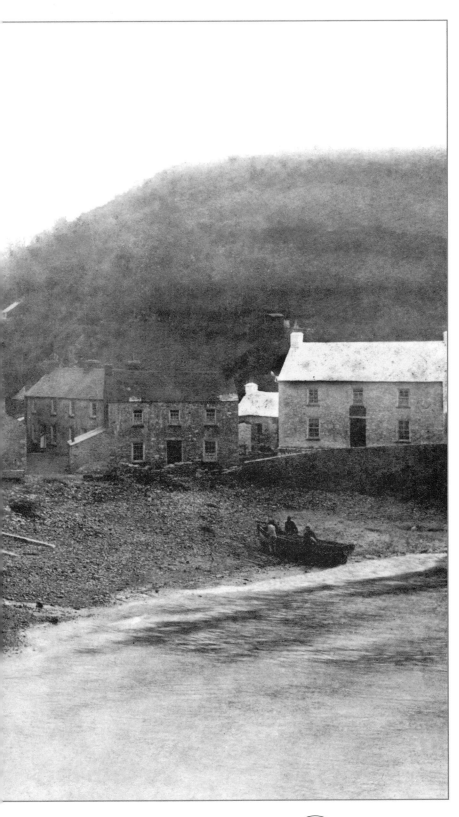

**Little Haven
The Beach 1898** 41101
Strawberry Hill, above
the village, was the site
of an Iron Age fort. A
boat is being beached
to the right beyond the
slipway and other boats
in the centre.

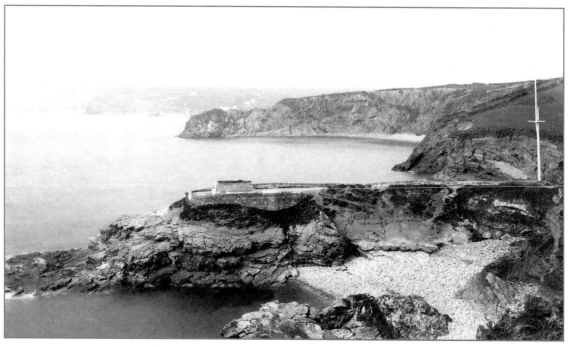

Little Haven, The Coast 1898 41103
The craggy, steep but captivating coastline of the area is amply demonstrated in this view. It is a somewhat different story in the depths of winter, when this coast is regularly battered by storms.

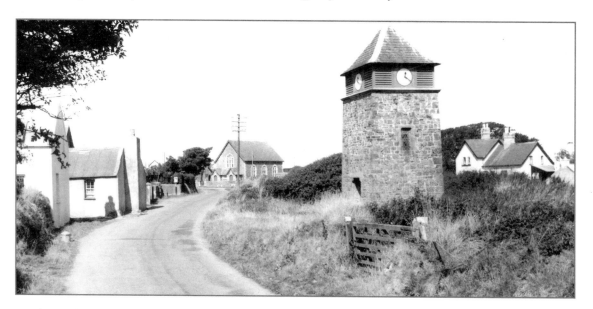

Marloes, The Old Clock Tower c1955 M204005
This is Pembrokeshire's most westerly village. The people of the village built its clock tower in honour of Lord Kensington. The following demonstrates how times have changed:
"Dwelling apart from the busier haunts of men, the good folk of this remote parish have kept pretty much to themselves, and have acquired the reputation of being a simple-minded, superstitious race - 'Marloes gulls', as the saying is."
H Thornhill Timmins, 1895

Marloes
Post Office c1955 M204007
In the days before the Post office, inhabitants of Marloes would engage themselves in a variety of other occupations. One being the collection of local leeches for Harley Street doctors, another being the collection of edible seaweed for the making of laver bread, and another 'wrecking'. The villagers were apparently notorious wreckers, attaching a lamp to a horse's tail and driving it around the sea cliffs to distract unfortunate mariners. One local story has it that when news of one particular wreck disrupted a Sunday sermon, the preacher broke off to say "Wait a moment, my brethren, and give your pastor a fair start!" He obviously felt he had lost his former youthful turn of speed.

▼ Dale, St Ann's Head c1960 D174031

On 7 August 1485 Henry Tudor landed at Mill Bay near Dale. The Welsh flocked to his standard. He met with a bard, Dafydd Llwyd, who prophesied his victory. He must have been somewhat nervous about speaking to the King on such a touchy subject, but his wife reputedly reassured him with the words: "If he wins, he'll never forget you; if he loses, you can forget him." He won, defeating Richard II to become King of England. The mast and the lighthouse were built on the site of St Ann's Chapel, a ruin by the reign of Elizabeth I. This sailing centre is reputedly the sunniest place in Wales.

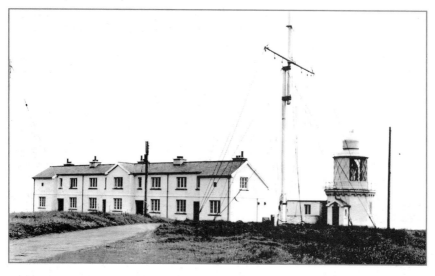

▲ Milford Haven Docks and Town c1964

M77032

Milford was once described as 'The finest port in Christendom'. Milford is in fact a Norse name; Hubba the Dane is said to have once wintered here, and Frobisher returned here after his second Arctic expedition. Milford was once a significant fishing port, landing skate, hake and conger among other varieties. Lord Nelson laid the foundation stone of the church, and Lady Hamilton once stayed here. The docks have a long history with both Royal Navy and seaplane connections. Note the signage for 'Wilson Smith's Excel Kippers'.

▼ Milford Haven, Swimming Pool c1955 M77018

This is an interesting juxtaposition of leisure and commerce. The Haven is a vast flooded valley renowned for its safe harbours. During the Civil Wars it once sheltered the Parliamentary fleet, which in turn prevented the Royalist capture of Pembroke Castle. According to Defoe (a 17th-century traveller), one Mr Camden previously described the Haven as follows: "... it contains 16 creeks, 5 great bays and 13 good roads for shipping, all distinguished as such for their names; and some say a thousand of ships may ride in it and not the topmast of one be seen from the other."

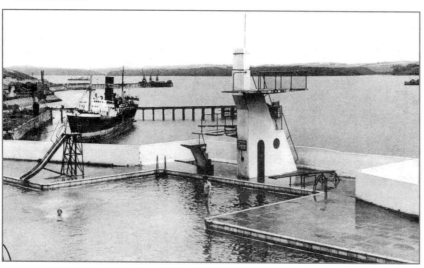

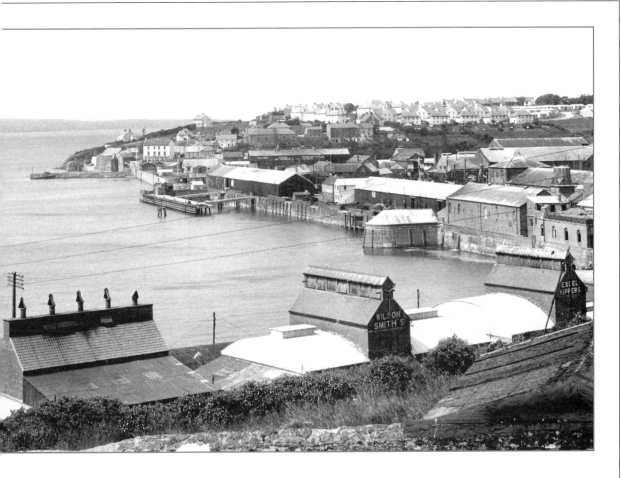

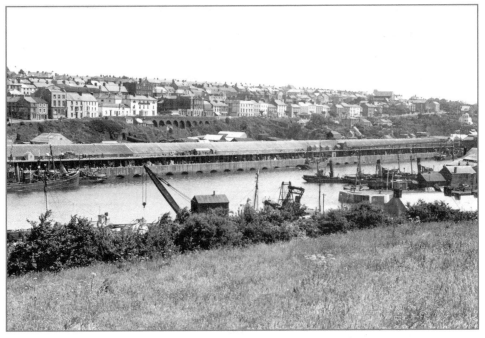

◄ Milford Haven Docks c1955

M77034

The turning point for Milford was Sir William Hamilton's obtaining of an Act of Parliament in 1790 to build quays and docks.

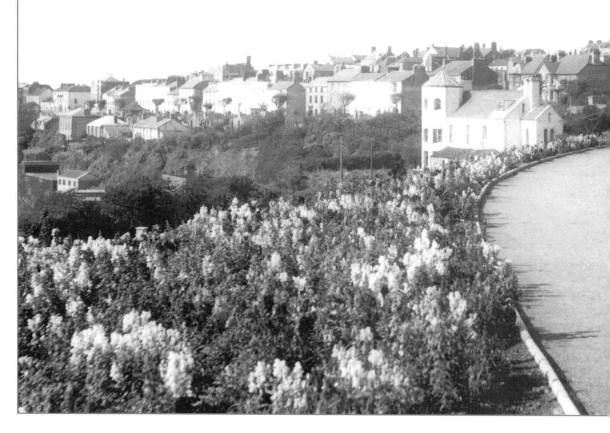

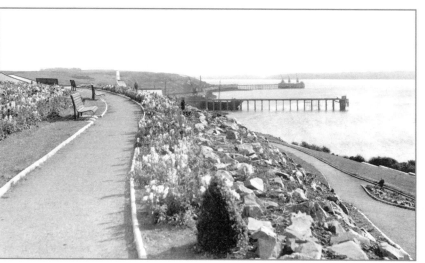

◀ **Milford Haven
The Rath c1960** M77049
Lord Nelson approved of
Milford Haven, even
comparing it favourably with
Trincomalee in Ceylon.
Milford Docks were
completed in 1888 in time
for a fishing bonanza in
1900-1914 when Milford
was found to be close to
very rich fishing grounds.
By 1904 there were 66
trawlers and 150 smacks
operating from here. By
1914, 2,000 people were
employed in the fishing
industry.

◄ Milford Haven The Rath c1960

M77042

Charles Francis Greville persuaded a colony of Quaker whalers in Dartmouth, Nova Scotia (to where they had emigrated from Nantucket to escape the ravages of the American War of Independence) to come to Milford. They traded in spermaceti to fuel London oil lamps, and left their permanent stamp in such street names as 'Starbuck Road' and 'Nantucket Avenue'.

"O for a horse with wings! - Hearst thou, Pisanio?
He is at Milford-Haven: read and tell me
How far 'tis thither ... how far it is
To this same blèssed Milford: and by the way,
Tell me how Wales was made so happy as
To inherit such a haven."
William Shakespeare, Cymbeline (Act 3, scene 2)

▼ Milford Haven, Aerial View c1960 M77084

In August 1405 a substantial French army in excess of 10,000 men landed here at the request of Owain Glyndwr. A land dispute in 1814 led the Royal navy to abandon Milford and relocate the Pembroke Docks. A similar story applies to the Irish steam packet, which operated from here until 1836.

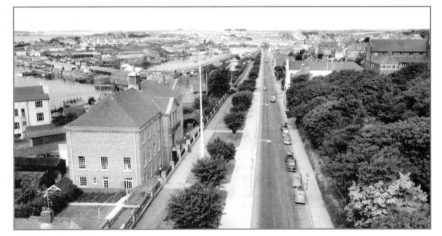

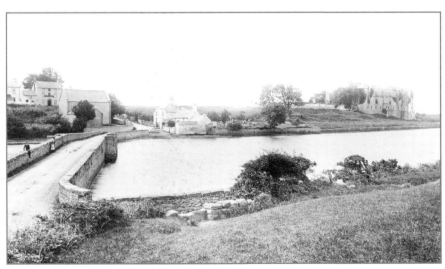

◄ Carew Castle Bridge 1890 27992

This castle was reputedly part of the dowry of Princess Nest, the bride of Gerald of Windsor in 1100. Originally a motte and bailey, it was extensively developed by Sir Nicholas Carew and, after his death in 1311, by his son. Note the casual spectators on the bridge – photography drew the attention of passers-by in those days!

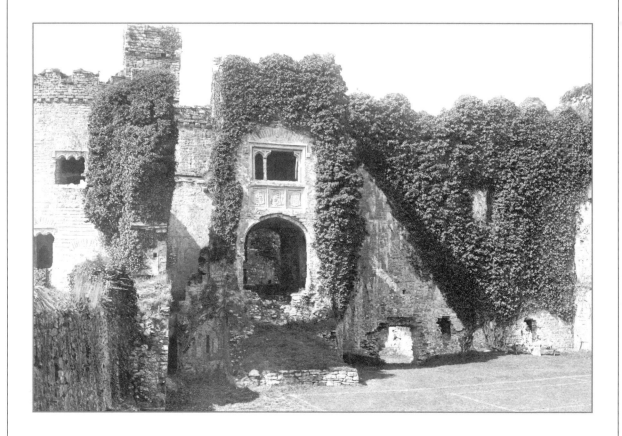

Carew Castle 1890 27998
This is another view of this splendid Norman castle, built on the site of a Romano-British fortress by Gerald de Windsor as a wooden stronghold. His descendant, Nicholas de Carew, built much of the stone structure we can see today. In 1480 the Castle was leased to a Welsh lord, Rhys ap Thomas, who rebuilt and extended it. He was host to the last great tournament held in Wales – 600 knights feasted and jousted here for five days to celebrate him being made a Knight of the Garter. Today the ivy has been removed and the buildings have been carefully preserved. The tennis courts marked out in the foreground are now not in evidence!

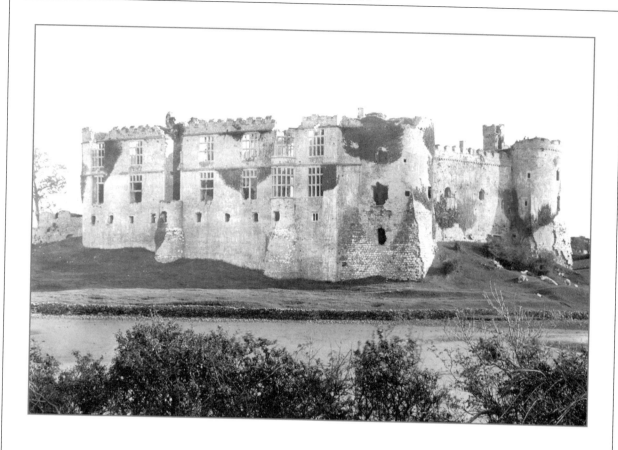

Carew Castle
From the North-West 1893 32816

The English Crown did not always hold the family in such favour. Rhys ap Thomas's grandson was executed for treason and the Castle was held forfeit to the Crown. In 1558 Queen Mary awarded the governorship of the Castle to Sir John Perrot of Haroldston, who extended it further, building the range on the north side of the court in this view. However, before he could enjoy the fruits of his labour, he was convicted of treason and died of pneumonia in the Tower of London.

The castle was originally garrisoned by the Royalists in the mid-17th-century Civil Wars. It was captured by the Parliamentarians commanded by Colonel John Poyer in 1645, and re-captured in May of the same year in a ferocious assault by a Royalist force, commanded by Colonel Gerard. The Castle fell to yet another Parliamentarian attack by forces commanded by Colonel Rowland Laugharne, who breached the south wall. This last assault resulted in the destruction of many buildings within the courtyard. Today there is a splendid lake in the foreground.

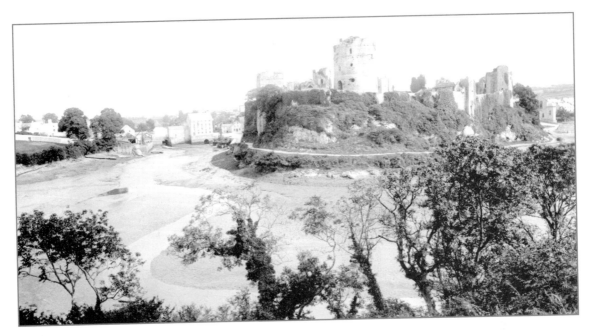

Pembroke, The Castle 1890 27955
The castle began its life as a far humbler structure than we enjoy today, once described as "... a slender fortress of stakes and earth". This view of the Castle perhaps best illustrates its superb defensive position. First fortified with a wooden structure in 1093; the Castle was the only one in the area not to fall when the Welsh rose against the Normans in 1094.

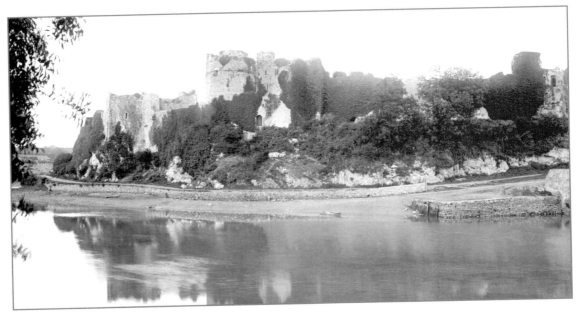

Pembroke, The Castle 1890 27957
The fortifications of the castle once surrounded the entire town to protect it from attack. Pembroke was also an important port and quays can still be seen under its walls. The Castle owes its origins to Roger de Montgomery, the Earl of Shrewsbury, who invaded Dyfed shortly after the Conquest in 1093. The vegetation clearly in evidence here and in the previous photograph, was removed after Major General Sir Ivor Philipps acquired the Castle in 1928. The new owner also undertook some restoration of the 17th-century damage.

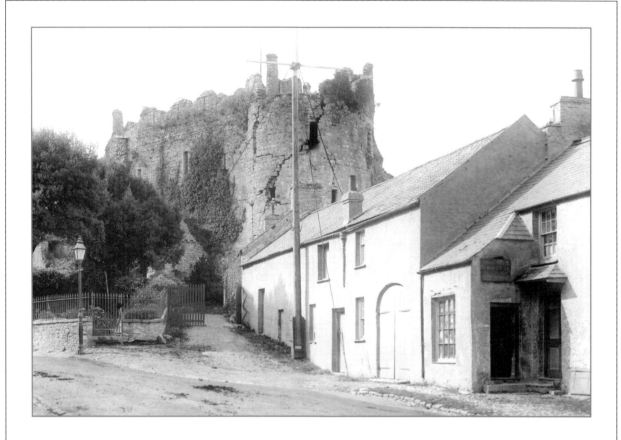

Pembroke
The Castle 1890 27959
The stone keep, or Great Tower, the walls of the inner ward and
hall were built by William Marshall. He became Earl of Pembroke
after his marriage to Isabel, heiress of Richard de Clare
('Strongbow'), the previous Earl of the county. At the outset of the
Civil Wars in the mid-17th century the Castle was first held for
Parliament under John Poyer, but subsequently changed sides in
1648. It was declared for the King when Poyer and Laugharne
became disenchanted with Parliament. Oliver Cromwell conducted
the seven-week siege in person and the Castle fell. Poyer was
executed, and the walls and towers were 'slighted' to prevent the
fortress being useful to the Royalist cause in future.

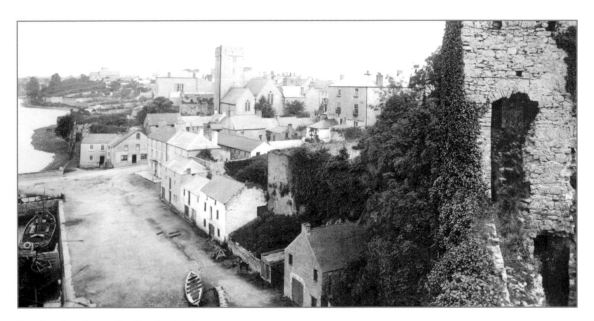

Pembroke, From the Castle 1890 27966
This was taken from the Castle, looking over the town with the Norman church of St Mary's in the centre, which was renovated in 1879 and the west doorway added. Note the two boats, one lying in the street and another below the wall to the left. The Castle was once besieged by the Welsh and its commander, Gerald of Windsor, who although desperately short of provisions, threw four flitches of bacon over the walls to the besieging Welsh, to indicate that they had plenty of food. He also took the precaution of writing to Arnulph de Montgomery to tell him they had no need of reinforcements, but instructed the messenger to 'lose' the message where the Welsh would find it. The besiegers lost heart, gave up and left.

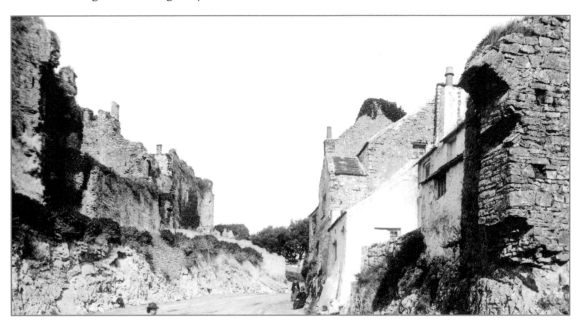

Pembroke, Castle Hill 1890 27971
The Castle is situated in a strong defensive position, bordered on three sides by the tidal reaches of the Haven, and its landward side protected by a ditch. Originally a hastily-built wooden fortilice, it was rebuilt in stone by Arnulph de Montgomery.

"I confess I have lived very loosely ... though I was once low yet I have become very high ... but now I must leave all ... although my fortune changed my affections to the Parliament did not alter ... I was always honest with them until an unhappy disaster which hath brought this misery to me."

So said Poyer after he had prayed and before he raised his hand to indicate he was ready. He was shot by firing squad, 25 April 1649.

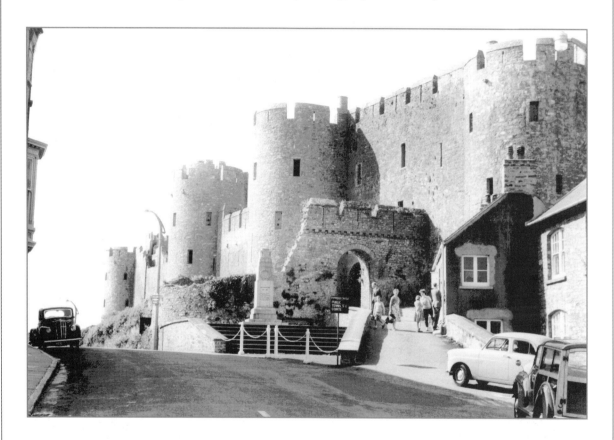

Pembroke
The Castle c1955 P22128

Disillusioned with their former masters in Parliament, Poyer and Laugharne, two former Parliamentarian commanders, switched sides during the Civil Wars and held Pembroke Castle for the Royalist cause. Cromwell undertook their subjugation personally, as he was outraged by what he saw as blatant treachery from former comrades-in-arms. He swept into Wales at the head of a strong force, mopped up Tenby en route (capturing another renegade, Powell, in the process), and besieged Pembroke Castle. After a lengthy siege, the Castle finally fell when the water supply was poisoned. Poyer and Laugharne capitulated, but not before the traitor was caught and poetically buried in the water pit. All three commanders were put on trial in London and the court decided that only one should suffer the death penalty. The story goes that they refused to draw lots, and so a child drew for them. Two bits of paper were inscribed "Life Given of God" and the third was left blank. Poyer drew the blank, and he was shot in Covent Garden Market on 25 April 1649. Note the sign advertising public tennis courts on the Castle green.

**Pembroke
High Street 1890**
27972
The tower of St Mary's
church rises over the
rooftops to the left of
the picture. The portico
of the Lion Hotel is
seen on the right.

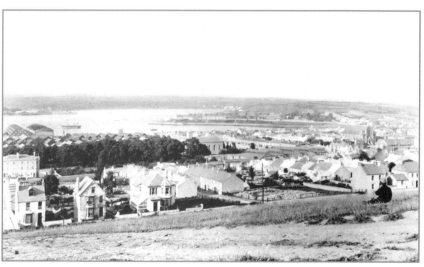

◄ **Pembroke Dock
From Barrack Hill 1890**
27973
In 1928 HMS *Warrior*, Britain's prototype ironclad was moved here to act as a hulk. This vessel has now been recovered and moved to Portsmouth, and is used as an excellent floating museum. The Royal dockyard was moved here from Milford but was closed in 1926. The Sunderland flying boat base operated here during the years of the Second World War and continued up until 1958.

◄ **Pembroke
High Street 1936**

87422

This later view has more of St Mary's in evidence. There is a dramatic change in the clock tower, it evidently having been rebuilt between these dates. The Lion Hotel now also has the benefit of a hanging advertising board.

▼ **Pembroke Dock
From Barrack Hill
c1960** P203026

During the First World War the German Navy undertook a devastating U-boat campaign in the Irish Sea. Fishguard and Pembroke acted as reception points for the crews and passengers of the sunken ships. Pembroke is now also a popular yachting, building and repair centre.

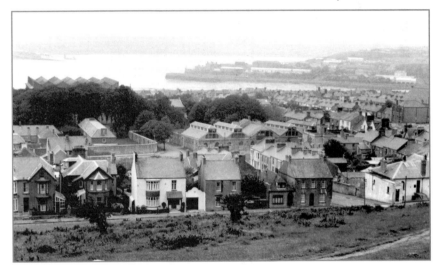

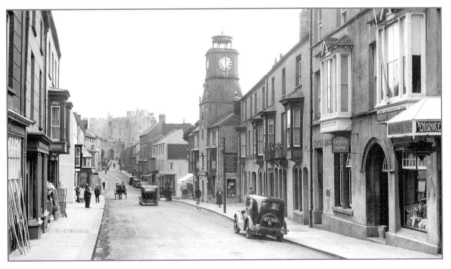

◄ **Pembroke
Town Centre 1936**

87421

Looking towards the Castle at the end of the street, note the agricultural implements on sale on the left, the Lion Hotel further down the street, and on the right-hand side the arched entrance to the British Legion Club. There is also a branch of Lloyds Bank, a sign advertising WH Smith circulating library and the impressive clock tower.

▼ **Pembroke Dock, Dimond Street c1955** P203073
Pembroke Dock was a favourite target for the German *Luftwaffe*
during World War II. The docks, established in 1814, went on to build
some 260 ships here. A branch of Barclays Bank is on the left and
WH Smith is on the right of the picture.

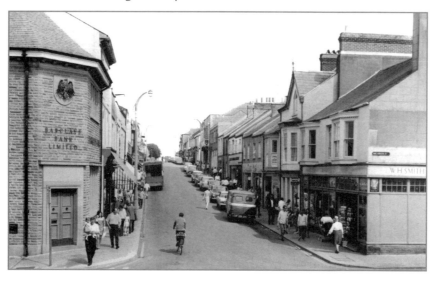

▼ **Pembroke Dock, Dimond Street c1960** P203042
The Naval dockyard was abruptly closed in 1926 to be made over to care and
maintenance only, and the local economy suffered terribly, resulting in
unemployment rising to 25%. There was a revival of fortunes in 1936 and during
WWII the Haven was an assembly point for some Atlantic convoys. During the war
some 17,000 vessels are thought to have sailed from here. This, rather
unsurprisingly, attracted the attention of the *Luftwaffe* and the town and docks
were comprehensively bombed. Branches of Taylors and Woolworth's are on the
left and WH Smith on the right.

▲ **Pembroke
Main Street c1955**
P22005
Dylan Thomas, in his
Under Milk Wood, wrote:
"In Pembroke City when I
was young, I lived by the
Castle Keep. Sixpence a
week was my wages, for
working for the chimbley
sweep." The Lion Hotel
on the left is undergoing
repairs, as can be seen
by the presence of
scaffolding and a ladder
outside.

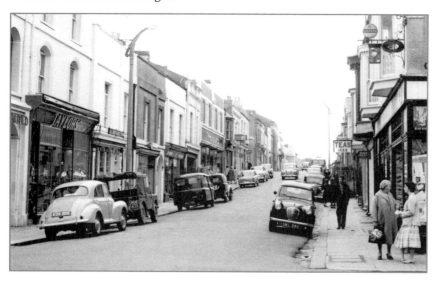

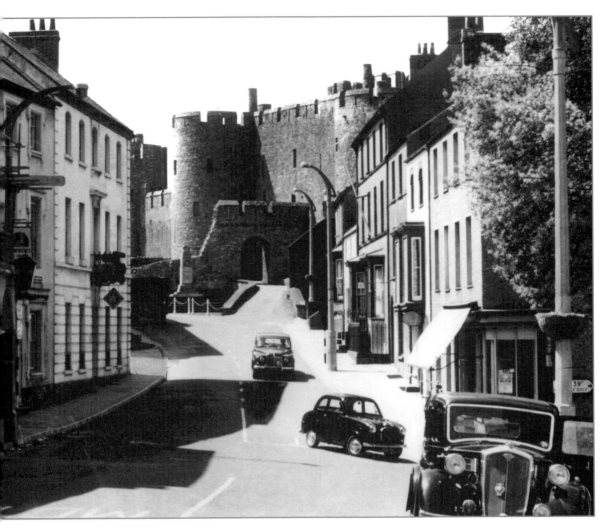

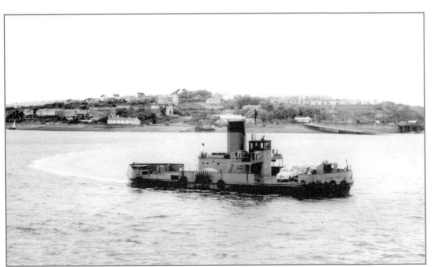

◀ **Pembroke Dock
Car Ferry to Neyland
c1960** P203057B
This is a splendid view of
the paddle-driven 'Cleddau
Queen' with cars on its
deck. The slipway is visible
in the background.

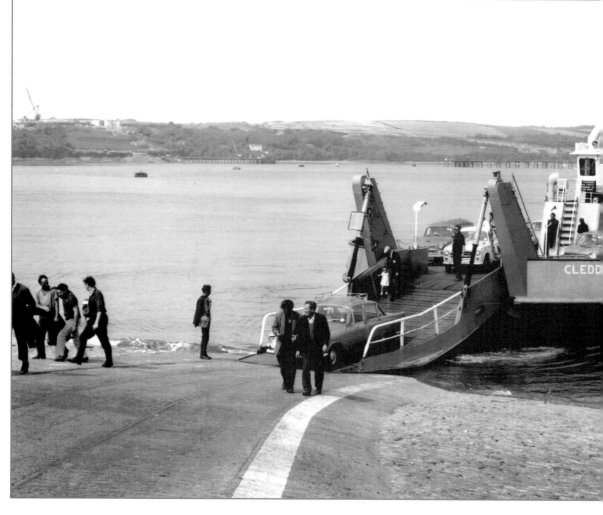

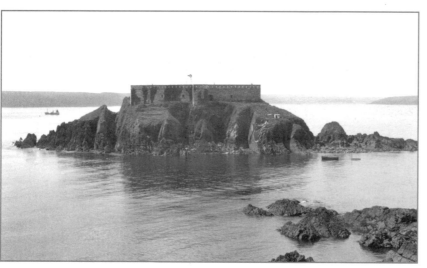

◄ Angle
Thorne Island c1965
A188043
'Angle' derives from 'In Angulo', from its position at the junction of where the Milford Haven empties into the sea. The fort was built in 1854 as a shore battery of nine guns. Note the steps leading up from the landing point.

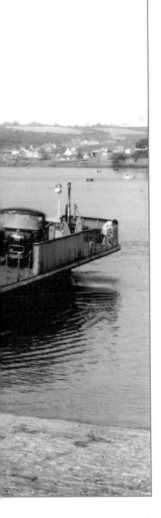

◄ **Pembroke Dock
Pembroke Ferry
c1960** P203075
The name of the ferry is
'Cleddau King', after the
Western and Eastern
Cleddau rivers which
feed into the Haven.
Their role has now been
taken by the road
bridge.

▼ **Angle
Village c1965** A188044
This feudal-pattern village
has the church of St
Mary (restored 1850s) at
its heart. There is also a
fishermen's chapel in the
churchyard built over a
1447 crypt. The street is
lined with colour-washed
cottages and evidence of
Norman strip farming can
also be seen. Note the
footbridge centre left.

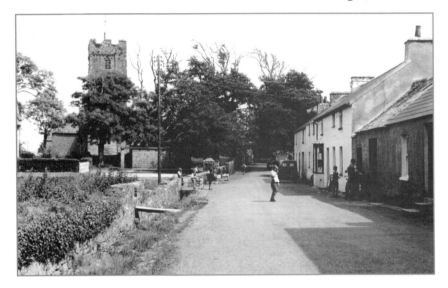

◄ **Angle
Angle Bay c1965**
A188077
With a gritty foreshore
and good anchorage,
there is a long sea-faring
tradition here with many
tales of shipwrecks and
smuggling. The local
public house, Point
House, once claimed that
the best anchorage to be
had was so close to Point
House that the clock in
the hall could be read
through the front door.

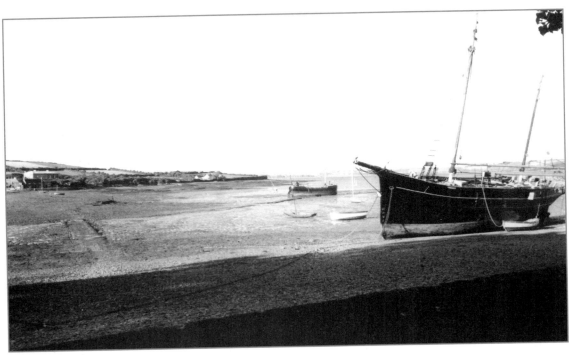

Angle, Angle Bay c1965 A188078
On this southern arm of the Haven, Angle Bay boasts fine views right across the Milford Haven. There are several beached boats, the first complete with tender.

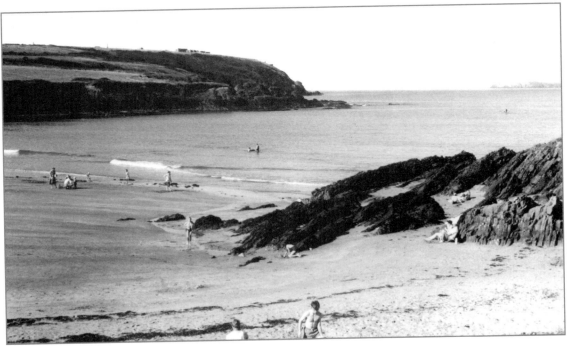

Angle, West Angle Bay c1965 A188085
Summers days on the beach, sand castles, swimming in the sea ... all timeless British preoccupations ... and fine views across the Milford Haven.

Castlemartin
The Roundabout c1955 C374003

Once the location of a ring work and bailey castle, then dominated by an MoD firing range, Castlemartin began life as a 'rath' or stockaded enclosure of Irish origin. George Owen described it as follows:

"The chiefest corn land in Pembrokeshire is the hundred of Castlemartin as that which yieldeth the best and finest grain and most abundance, being a country itself naturally fit and apt for corn."

It was later famed for its 'Castlemartin Black Cattle', known for their hardiness and long drooping horns. They were later merged into the Welsh Black variety.

▼ Bosherston, The Lily Pools c1955 B468001

Known as 'Stackpole Bosher' in the 13th century, these pools are actually three streams intentionally blocked off by sandbars. The legend goes that this is where Arthur yielded up Excalibur to the Lady of the Lake. The pools are famed for their excellent pike fishing and as a habitat for wildlife.

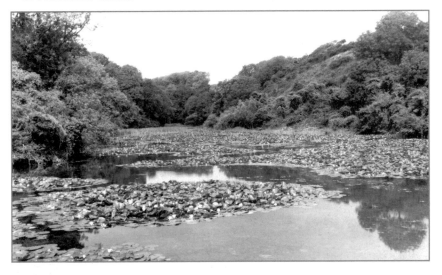

▼ Bosherston, Stack Rocks c1955 B468002

These spectacular rock formations were crafted by the waves from a collapsed arch. They are home to colonies of guillemots, razorbills and kittiwakes.

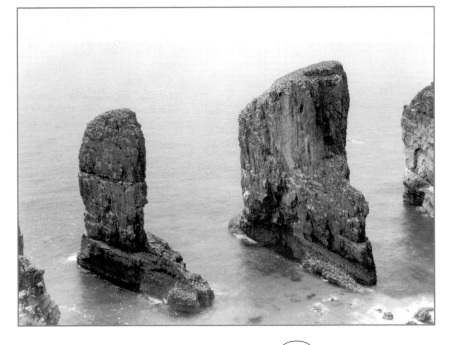

▲ Bosherston St Michael's and All Angels Church c1955 B468007
This 13th-century, cruciform country church in its placid setting has a preaching cross (possibly 14th-century) in the churchyard, visible here to the left of the lancet windows. It was restored in 1855.

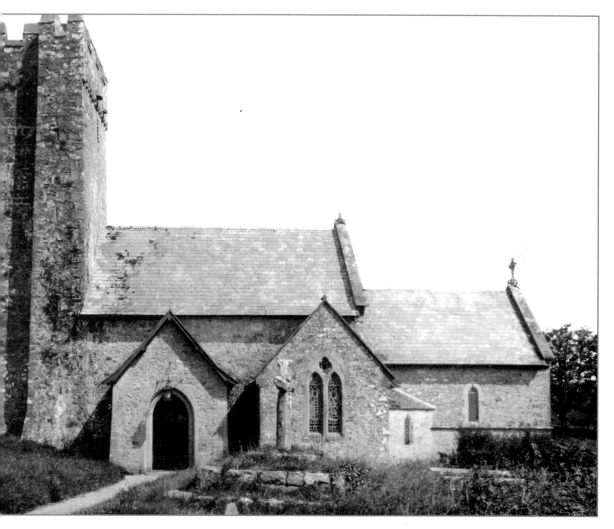

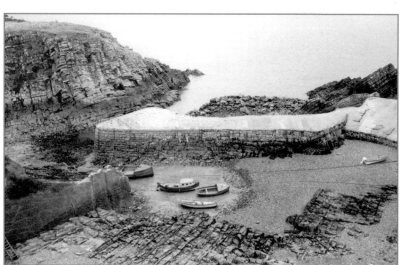

◀ **Bosherston**
Stackpole Quay c1955 B468044
This is reputed to be the smallest harbour in Britain, and was built to import coal and export limestone. There is a romantic explanation for the manor coming into the ownership of the Earl of Cawdor. Alexander Campbell (heir to the Earldom of Cawdor), was good friends with Gilbert Lord of Stackpole. He spent time with his friend at Stackpole and fell in love with Gilbert's sister. She inherited Stackpole from Gilbert and married Alexander.

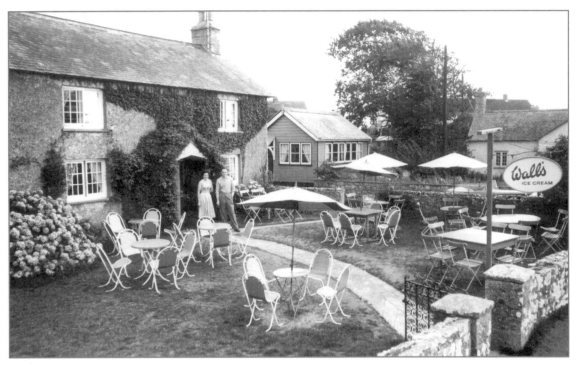

Bosherston, Tea Gardens c1955 B468060
This photographs shows tea on the lawn, Walls ice-cream and Mr and Mrs Host in attendance.

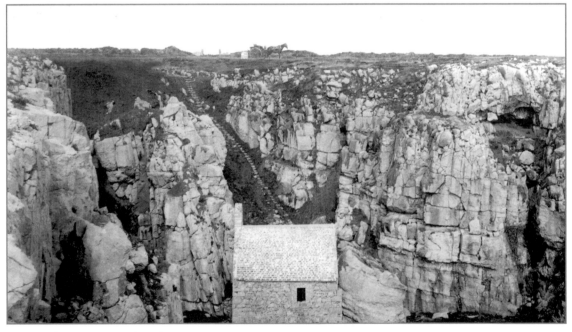

St Govan's Head, Chapel and Steps 1893 32819
A legend says that the chapel's silver bell was once stolen by pirates whose ship was promptly wrecked, killing all on board. The bell was recovered and encased in rock, which would ring out when struck. Note the steps leading from the cliff top; it is said that they never count the same going up as going down.

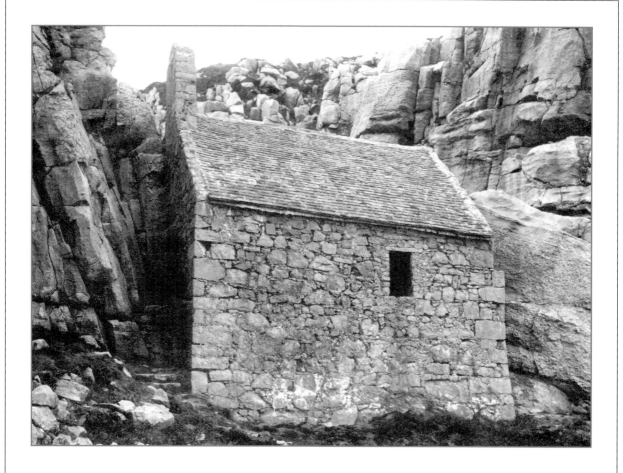

St Govan's Head
Chapel 1890 24928

The present chapel was built in the 13th century and contains an altar, a bench and a cell hewn out of the rock. It is thought the original chapel or hermitage dates from the 5th century. Legends as to its original ownership abound. One has it that it was the retreat of Cofen, wife of a king of Glamorgan, another that this is where Sir Gawaine became a hermit after King Arthur's death. A third is as follows:

"Here, according to a curious old legend, St Govan sought shelter from his pagan enemies; whereupon the massy rock closed over him and hid him from his pursuers, opening again to release the pious anchorite as soon as the chase was overpassed." (H Thornhill Timmins, 1895)

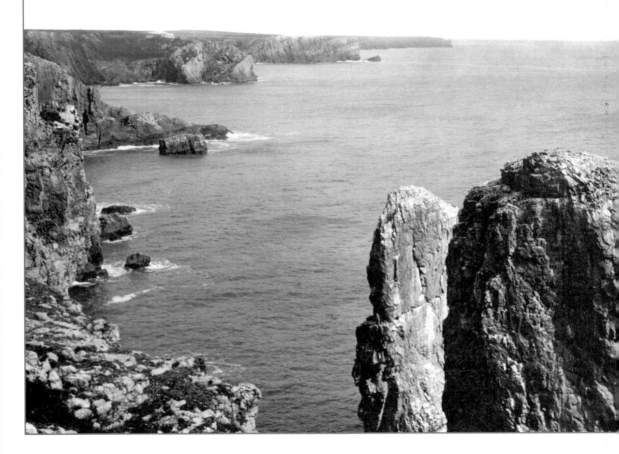

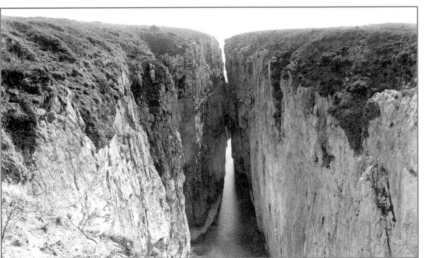

◀ **St Govan's Head
Huntsman's Leap
1893** 32821
The cliffs were so-named
after a rider, galloping
his horse along the cliffs
and unaware of the
impending drop into the
sea, leapt across the
chasm. He landed safely
on the other side, but
looking back and
realising what he had
done, promptly died
from sheer fright.

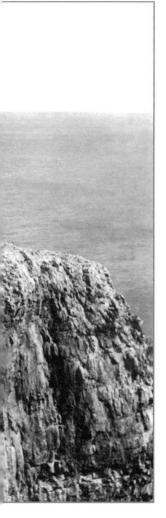

◀ **St Govan's Head
Coast View 1890** 27979
This 1820 account by
Thomas Roscoe describes
this view in better words
than I can muster:
"He was a painter. He had
followed the same wild
coast as myself. He had
seen the winged watches
on the Stacks, and stood
on the bold jutting
promontory of St. Govan,
looking out upon that
broad ocean, whose ever-
rolling waves fitly suggest
the idea of eternity."

▼ **Freshwater East
The Beach c1960**
F122015
This is an excellent view
of Freshwater's rolling
sandy beaches and the
scattering of caravans.

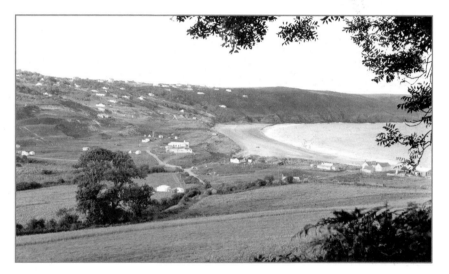

◀ **Lamphey
Church and Village
1890** 27986
This Norman church was
dedicated to St Tyfei. The
west wing was
constructed c1250 and
the east wing added
c1330. Robert Devereux,
the Earl of Essex and
favourite of Elizabeth I,
spent some of his youth
here. Note the cart on
the left of the picture.

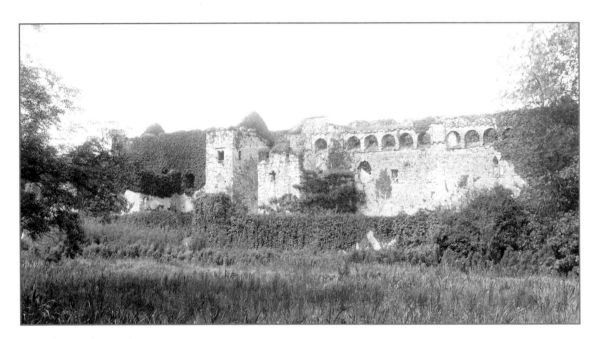

Lamphey, Palace Ruins 1890 27989
This was originally constructed as a rural retreat for the Bishop's of St David's, complete with orchards, fishponds, vegetable gardens, windmill and two watermills. The park also contained sixty deer. Now in the custodianship of CADW (Welsh Historic Monuments), these buildings have been sensitively renovated. The name, according to George Owen of Henllys in his 17th-century 'The Description of Pembrokeshire' is a corruption of 'Llandyfai', the church of St Tyfai (or 'Tyfei').

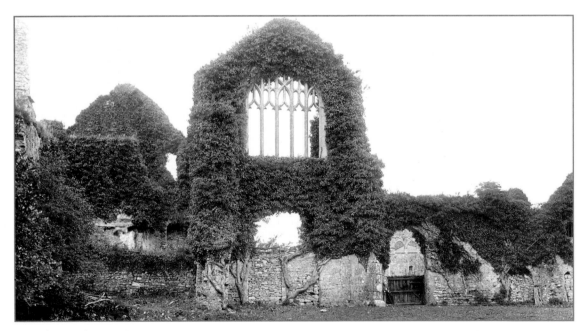

Lamphey, Palace Ruins 1890 27991
Lamphey was one of the seven palaces belonging to the Bishops of St David's – a rather grand holiday retreat! The grounds were once graced by herds of deer and several gardens. The Earl of Essex acquired it after the Dissolution of the Monasteries, but it rapidly fell into decay thereafter.

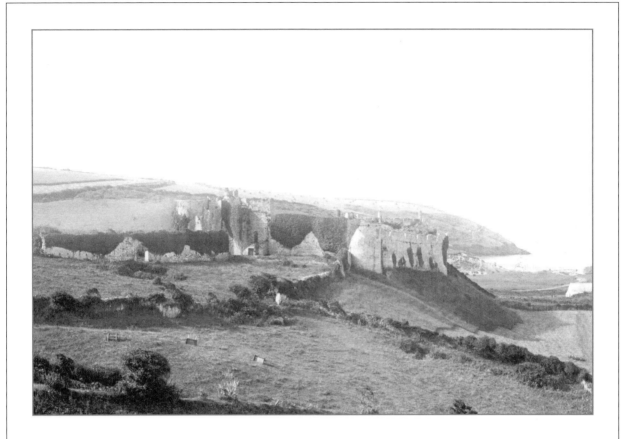

Manorbier
The Castle 1890 27981

This splendid Castle is six miles from Tenby, and has commanding
views. It is probably the oldest surviving stonework in the county.
It was originally an earth and timber structure begun by Odo de Barri
in the 12th century. Giraldus Cambrensis, the famous chronicler, was
born here and was obviously very attached to the place:
"It is excellently well defended by turrets and bulwarks and is situated
on the summit of a hill extending on the western side towards the sea-
port, having on the northern and southern sides a fine fish-pond
under its walls, as conspicuous for its grand appearance as for the
depth of its waters; and a beautiful orchard on the same side inclosed
on the one part by a vineyard ... It is evident, therefore, that Maenor
Pirr [Manorbier] is the pleasantest spot in Wales."

**Manorbier
The Castle and Village
1890** 27980

The Castle was rebuilt and improved over many years, and was garrisoned against the Welsh rebellions of Gruffydd ap Rhys in 1153 and Owain Glyndŵr during the early 15th century, but never suffered attack. The occupant during this latter uprising was Sir John Cornwall who was specifically instructed by Henry IV to fortify it in case of Welsh attack. It was again fortified for the Royalist cause, and occupied by Colonel Rowland Laugharne, during the Civil Wars but was also never attacked during this conflict. The last military occupancy was during the First World War, when some of the tower rooms were billets for soldiers. Note the haystack in the foreground and the Norman church of St James on the left.

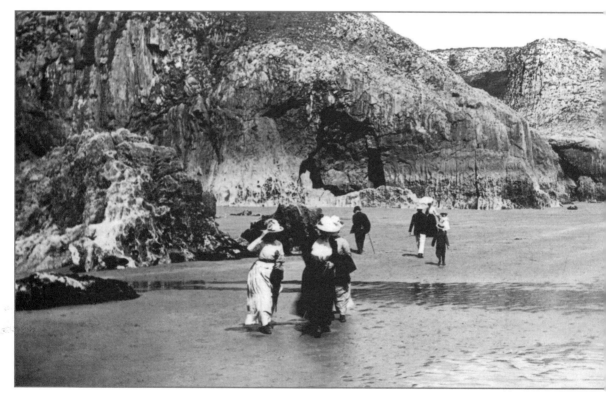

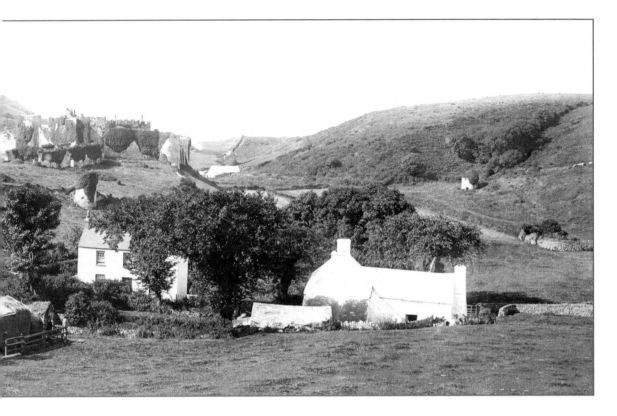

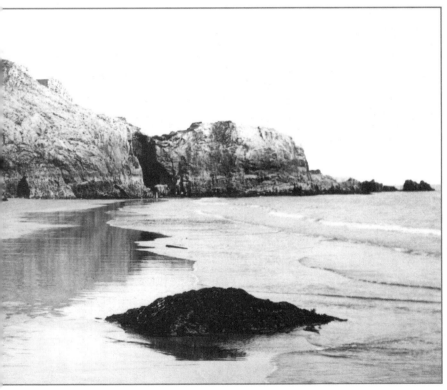

**Lydstep
Beach 1890** 28010
The "Sweet little cove of
Lidstep" (Gosse, 1886).
Caves and caverns in
these limestone cliffs can
be explored a low tide,
one is reputedly a
smugglers' cave. A
skeleton of a pig with a
tree trunk across its neck
and flint arrowheads in its
ribs was found in the bay.
The fashionable dresses
and hats worn by the
people in the photograph
hardly seem suitable
attire for a paddle!

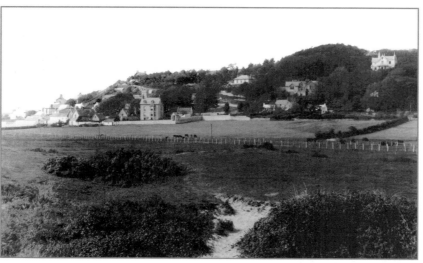

◀ **Penally**
Tenby 1893 32808
The name 'Penally' is a
corruption of 'Penalum',
and was the site of an
early religious
community. The Welsh
for Tenby is 'Dinbych-y-
Pysgod', the 'little fort of
the fishes'.

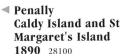

◀ **Penally**
Caldy Island and St Margaret's Island 1890 28100

This is an excellent view from Penally out towards these two historic islands that are connected by a thin strip of rock. St Margaret's was also known as 'Little Caldey'.

▼ **Tenby**
Parish Church 1890 24920

The dramatic 150 ft spire of this church dedicated to St Mary soars over the Tenby rooftops, and is reputedly the largest parish church in Wales. The tower was built in the 13th century and the spire in the 15th century. Giraldus Cambrensis was rector here in the 13th century. Robert Recorde, pioneer in the study of algebra, was born here in 1510. Augustus John was another native of the town. Note the painted wooden Manchester Warehouse Co. sign under the chimneys on the left, the ladder against the building further up the street, and the Royal Gatehouse Hotel carriage on the right under the Post Office sign.

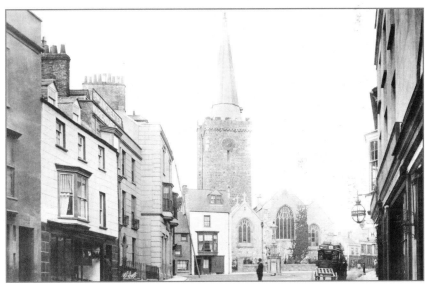

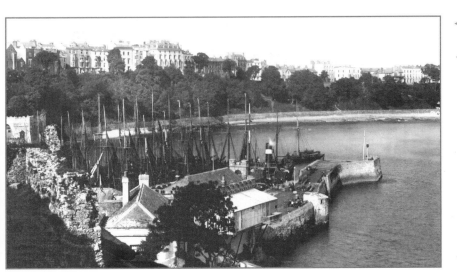

◀ **Tenby**
Harbour 1890 28027

In 1457 the Earl of Pembrokeshire helped the inhabitants to rebuild and strengthen the walls to guard against the Spanish Armada. The repairs were perhaps hastily conducted as the walls were in need of more work in 1558. Note the forest of masts and the steamer funnel in the centre of the picture.

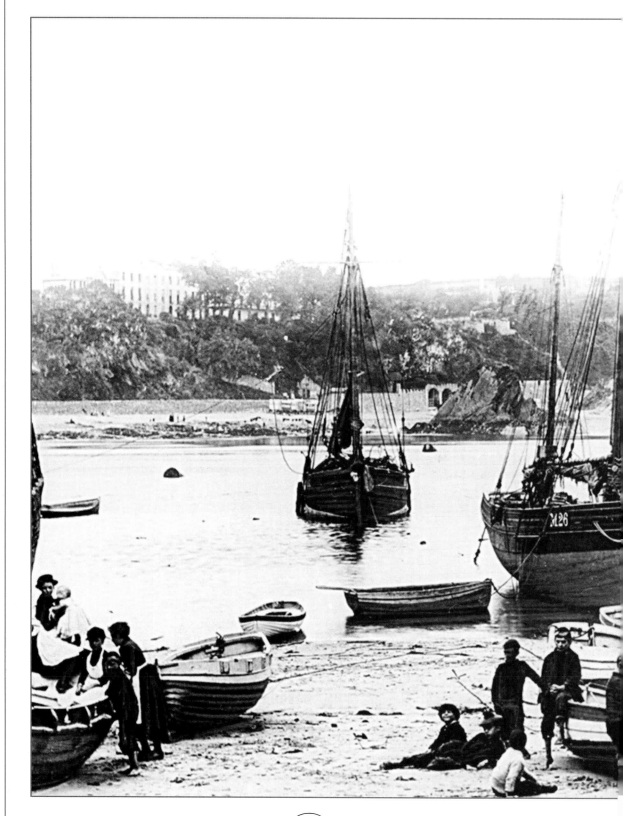

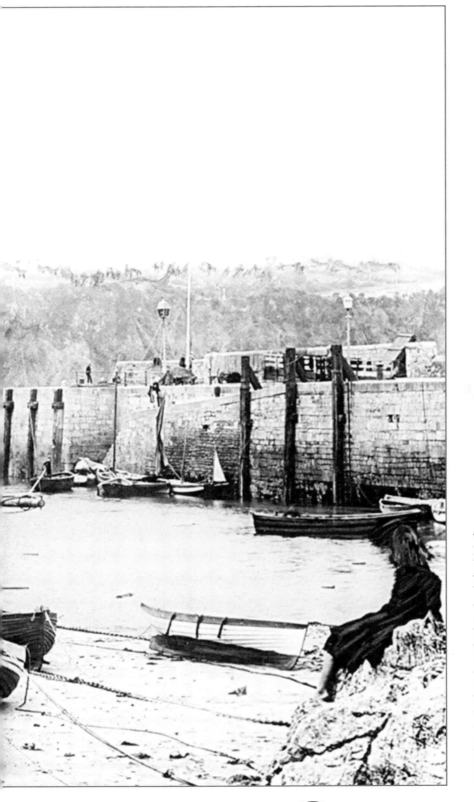

**Tenby
Harbour 1890** 28041
This is another excellent
view of the harbour.
There are many
children who have
presumably been drawn
to the permanent
excitement of a busy
port. "The Countrey,
especiallye of late years,
is fallen much to trade
to sea, and a great part
of the Countrye people
are seamen and
maryners ... many of
them continually
abroade at sea"
(George Owen, 1603).

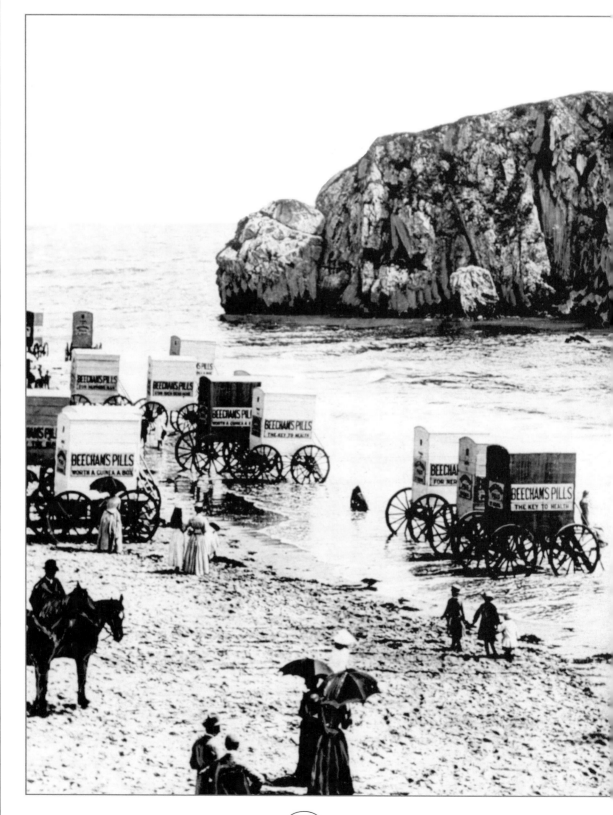

"Pleasant the fortress on the shore of the sea, Merry New Year on the beautiful headland, Louder the song of the bards at their mead Than the beat of the waves resounding below..."(Welsh poem)

Tenby
St Catherine's Island
1890 28064
Tenby perhaps began its life as a Norse settlement. It was seized by the Normans soon after the Conquest, and was captured by the Parliamentarians in 1644 during the Civil War. It was retaken by Cromwell in 1648 after its defection to the Royalist cause, and was bombarded twice from the sea. Fort St Catherine was completed in 1869 as a 6-gun defence, but none of its guns were ever fired in anger. Note the bathing machines.

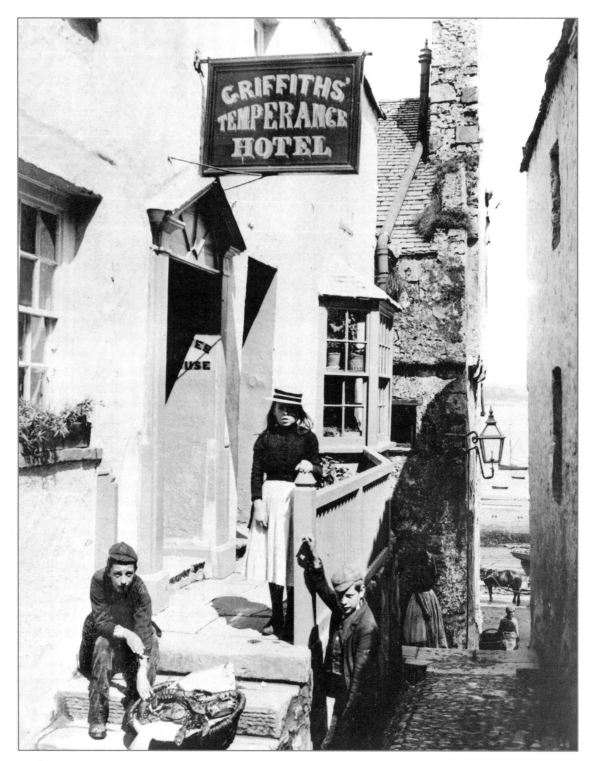

Tenby, Temperance Hotel 1890 28076
The Temperance movement was as significant here as it was in many Welsh towns. A boy is displaying an impressive basket of shellfish and an enormous flatfish.

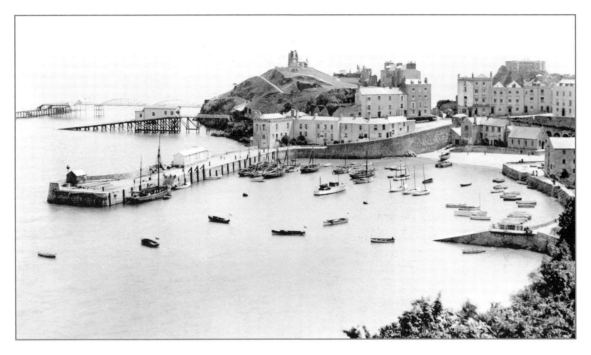

Tenby Harbour 1925 77263
The remains of the 13th-century castle are on the hill beyond the houses. The Pier, which has now been removed, and the slipway are to the left.

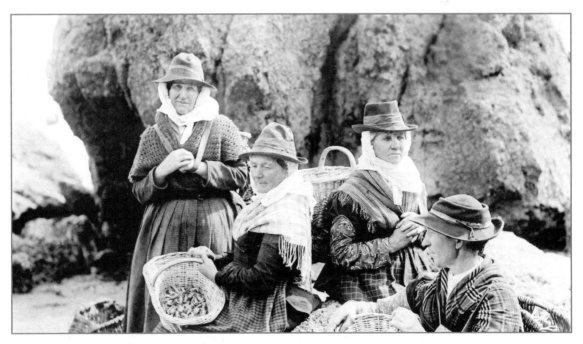

Tenby, Fishwives 1890 28091
Seen here are Tenby fishwives at their work, shrimping along the shore. Note the basket of shrimps, the hats and scarves of their traditional dress and the larger basket one lady has on her back. The town was not totally reliant on the fishing industry. In 1908 there were seventeen lime-kilns in operation, some of which were still working in 1948.

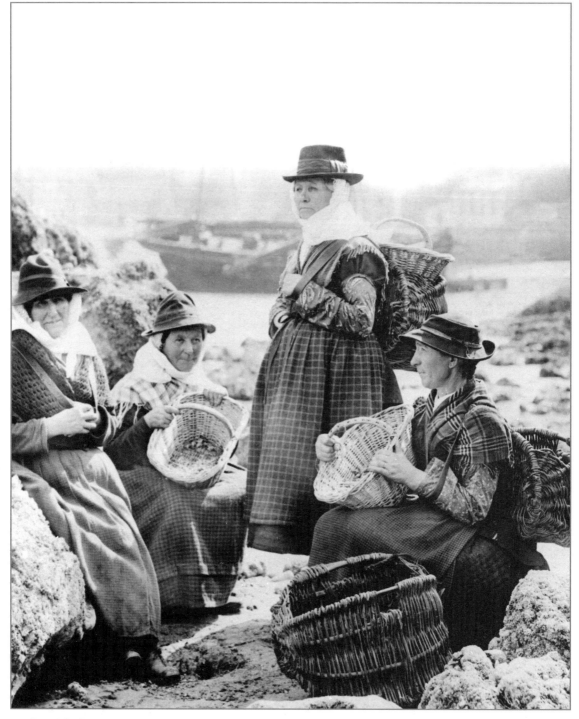

Tenby, Fishwives 1890 28093
Tenby's past is a turbulent one, not least at the hands of Welsh princes. The town was sacked by Maelgwyn in 1187 and again by Llywelyn the Last in 1260. In 1650-51 there was a devastating outbreak of plague which destroyed the town's trade and killed around 1,000 of the townspeople (roughly one third of the entire population). A fishing boat is in the background.

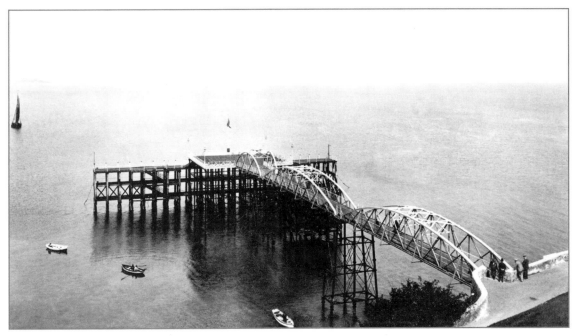

Tenby Pier 1899 43346
The town was granted its charter in 1402 but was only incorporated in 1581. The Pier shown here, with its dramatic three-span walkway, has now been removed. The town was very popular in the mid-18th century as a health resort, which resulted in many fine houses springing up.

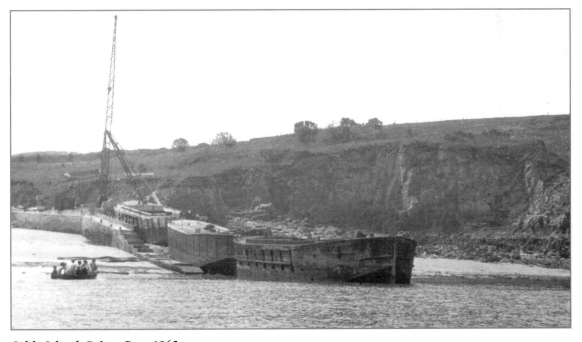

Caldy Island, Priory Bay c1965 C373001
Caldy Island (also spelt Caldey), from the Norse Keld (cold) eye (island), but originally 'Ynis Pyr', is one of the best-known of Pembrokeshire's sixteen offshore islands. Note the overcrowded rowing boat, the crane and the row of hulks.

◄ Caldy Island Village c1965 C373008
After the Dissolution of the Monasteries the island was mostly uninhabited, except by pirates seeking safe harbour. The island is 550 acres in total, and in prehistoric times, was connected to the mainland where we now have Caldy Sound.

◄ Caldy Island
The Slipway c1965
C373020

In 1136 the island was given to the Benedictine Abbey of Tiron in France, who also had a house at St Dogmael's. Here we see visitors to the island awaiting the ferryboat to return them to the mainland across Caldy Sound.

Caldy Island ►
The Calvary c1960
C373026

This is a reminder of the island's religious inhabitants, but the island is also home to many colonies of birds. John Ray had this to say in 1662: "[Caldy] had gulls, sea swallows, and puits, their nests so thick that a man can scarcely walk but he might set his foot upon them". Both communities dwell in perfect harmony.

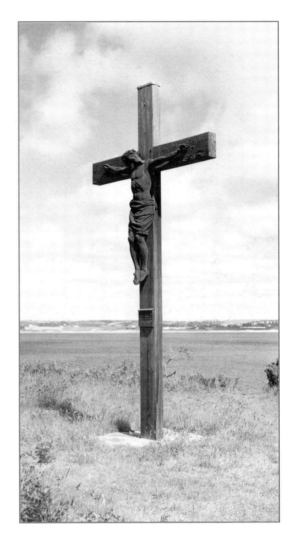

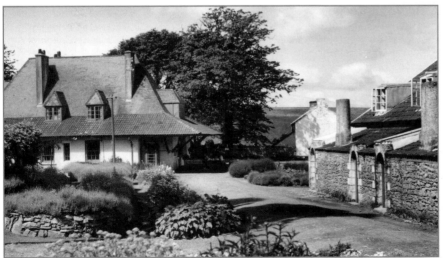

◄ Caldy Island
Village c1965 C373031
The building on the left is the present Post Office, under the shadow of the Priory itself.

▼ **Caldy Island, The Abbey c1960** C373047
There was an Anglican community here from 1906, which entered the Benedictine Order in 1913. This community relocated to Prinknash in Gloucestershire and the buildings were taken over by the present community of Cistercian monks.

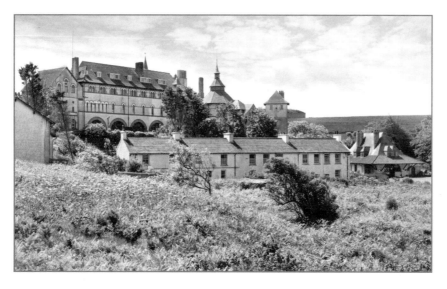

▼ **Caldy Island, The Lighthouse c1960** C373041
This lighthouse, which is on the highest point of the island (180 ft above sea level), was built in 1829 as a gas-burning light and has been automated since 1927. An inquisitive donkey grazes nearby.

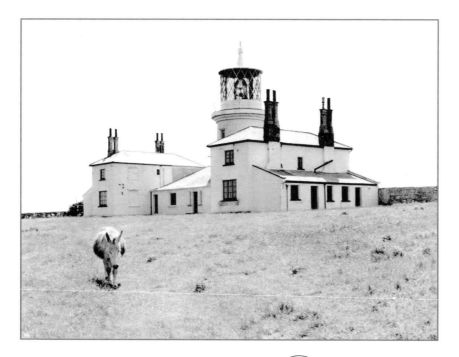

▲ **Gumfreston Church 1890** 24948
This charming 12th-century church is dedicated to St Lawrence. The chancel and south chapel date from the 14th century and the exceptionally tall tower was built about a century later. The church was restored in the 1860s and boasts wall paintings on the north wall of the nave. There are springs in the churchyard, and the church became a place of pilgrimage when it was thought the water had healing properties.

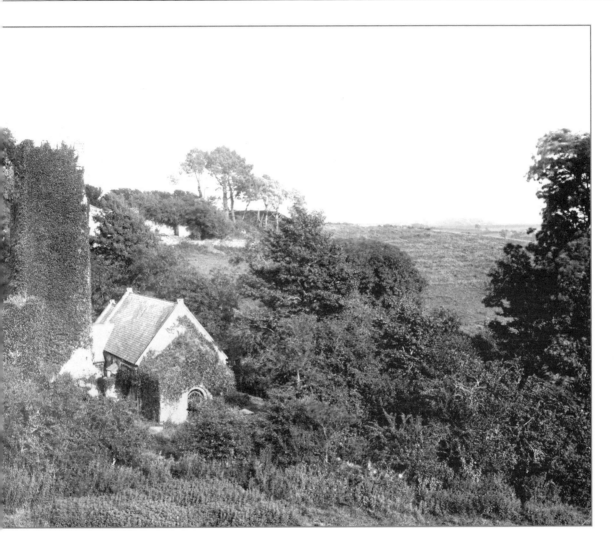

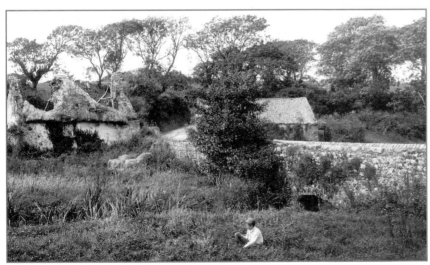

◀ **Gumfreston
Ruins and Mill 1890**
28103
Small vessels came up the
Ritec as far as Gumfreston
at high tide. Note the stone
bridge, tumbledown
building and the solitary boy
in the foreground.

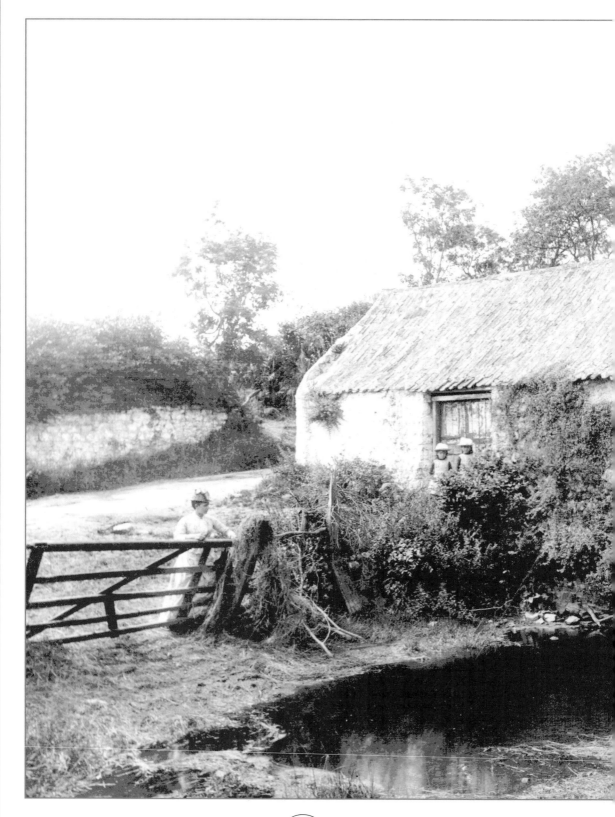

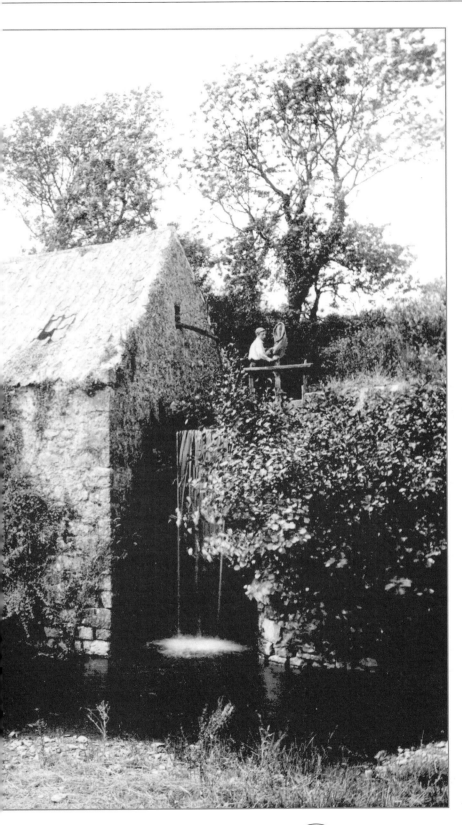

**Gumfreston
Water Mill 1890** 28104
Note the lady in her
bonnet leaning on the
gate, the millrace
emptying into the pond
and the hopeful boy
with his net above.

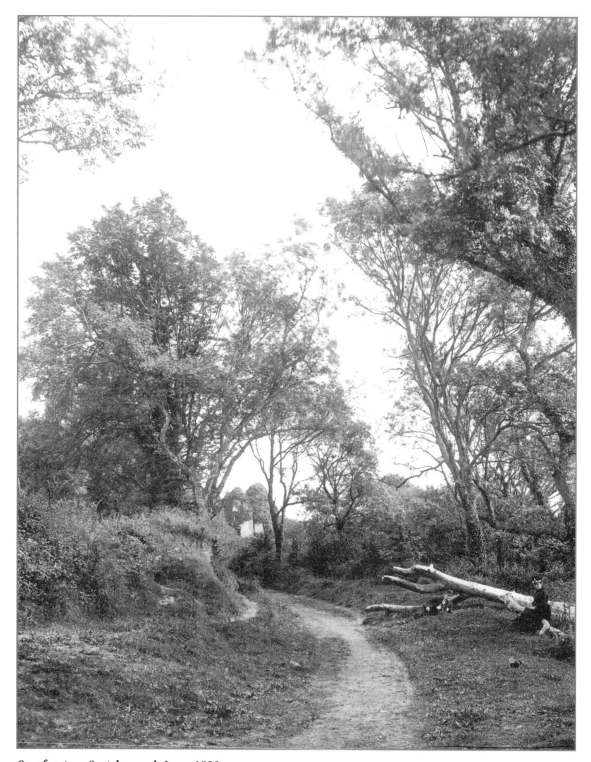

Gumfreston, Scotsborough Lane 1890 28107
This lovely leafy scene is somehow made complete by the attentive man below the fallen tree looking at the lady ...
who is paying rather more attention to the camera than perhaps she should under the circumstances.

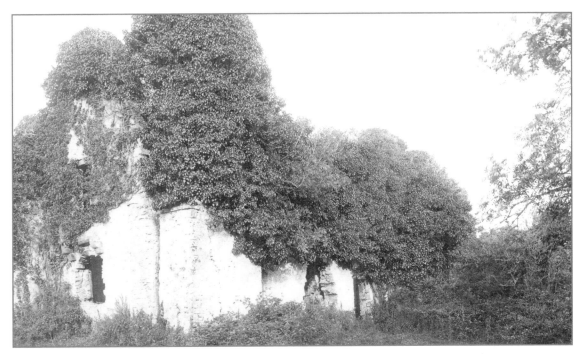

Gumfreston, Scotsborough Ruins 1890 28106
Scotsborough House was the home of the Perrott family from c1300 to 1614, wherupon it became the home of
Rhys ap Thomas.

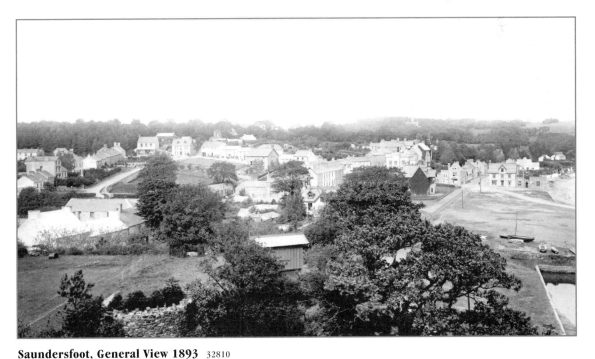

Saundersfoot, General View 1893 32810
The resort of Saundersfoot is set between Tenby and Amroth. Anthracite production was conducted on a relatively
large scale here, the harbour being the means by which it was 'exported'. The last mine closed in 1939, and the
harbour has since been developed as an excellent yachting harbour.

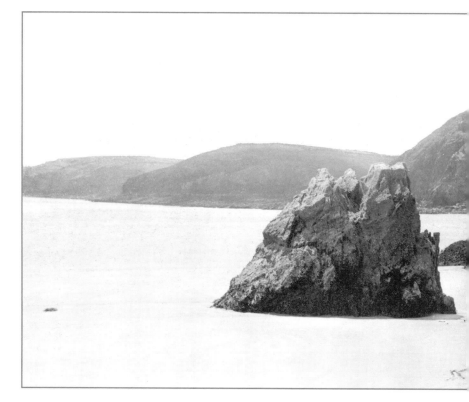

Saundersfoot Monkstone Sands 1890 28113
This attractive seaside resort with its sandy beach has always been a magnet for holidaymakers. A boy is sat on a rock in the centre of the picture - are the shapes in the sand his handiwork?

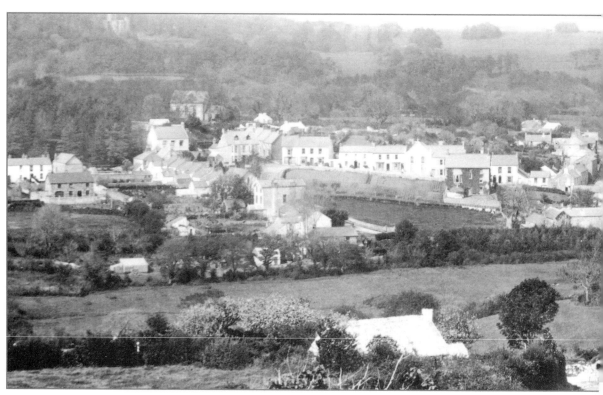

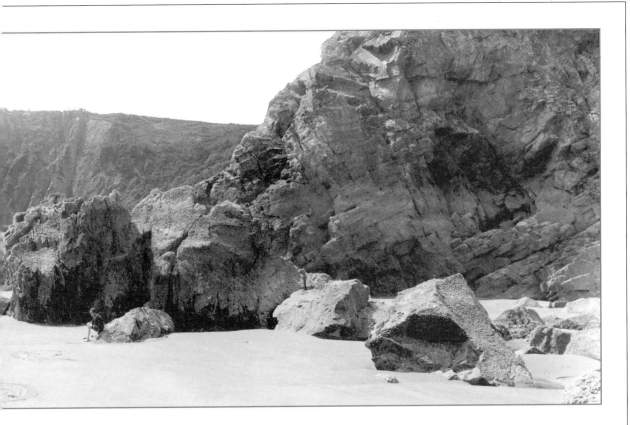

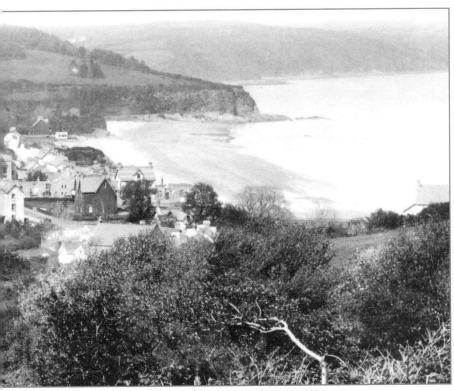

**Saundersfoot
From Griffithoon Hill
1898** 41072
We find in the 1325
accounts of the Earldom
of Pembroke a reference
to coal at Caytrath (the
wooded area behind
Saundersfoot): "... a mine
of sea coal ... paying a
yearly rent of 16 shillings
and four pence." The
coal mined here was
known for its good
heating and low ash
qualities.

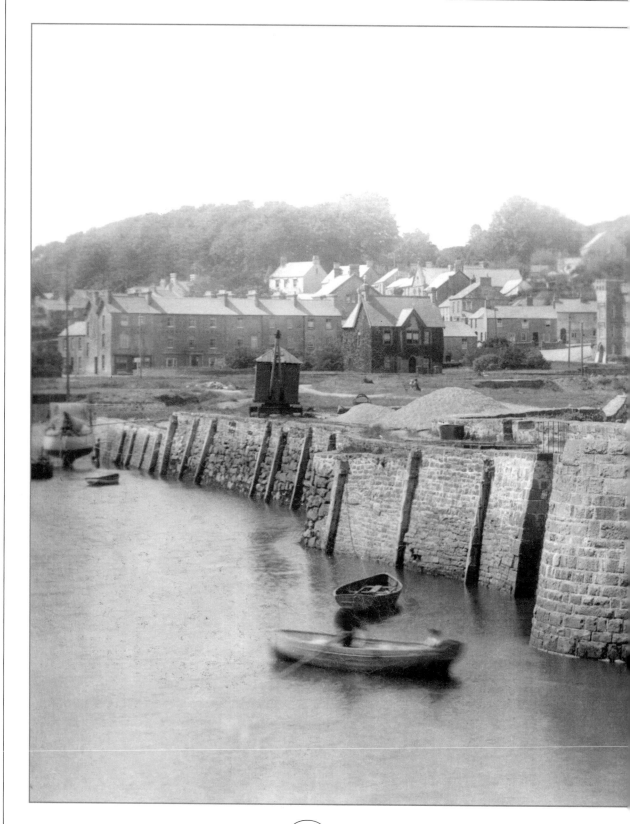

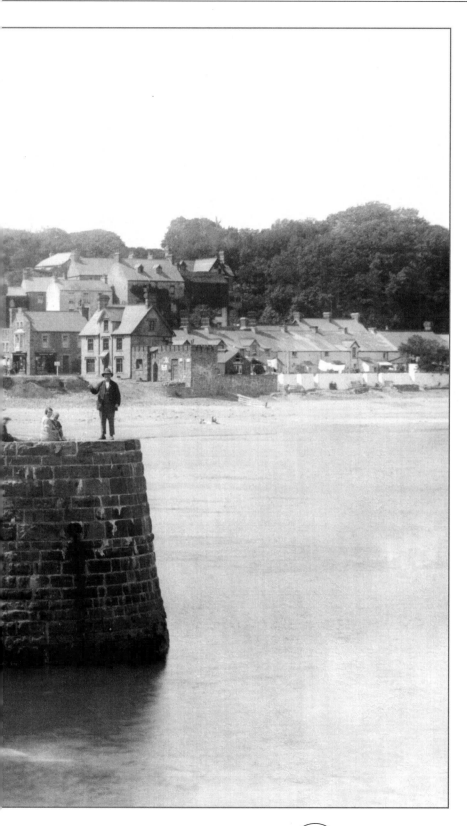

Saundersfoot Harbour 1925 77280
Coal was brought here by bullock wagon for loading onto ships. This all changed when the harbour was built in 1829, and various mineral railway lines made their way to the town. Note the friendly gentleman waving and the crane further down the wharf.

▼ Saundersfoot Harbour 1933 85587

By 1864 some 30,000 tons of coal were being shipped from here every year, as well as large quantities of pig-iron, which was made from iron ore extracted from the cliff faces between here and Amroth. Bonville's Court Colliery was nearby and employed 300 men at its peak. It closed in 1930. The last colliery in the area closed in 1939.

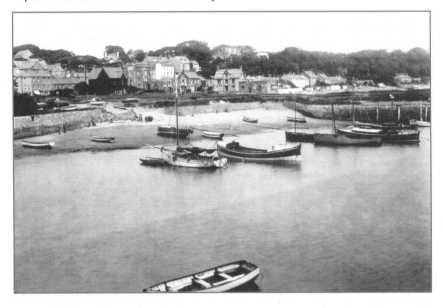

▼ Saundersfoot Harbour 1933 85589

This is a charming view of various sailing vessels and their masters. The railway tracks and trucks can be seen above the harbour wall, behind the boats.

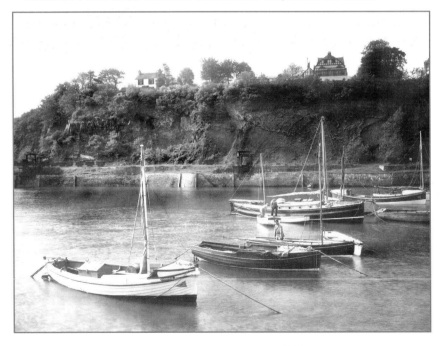

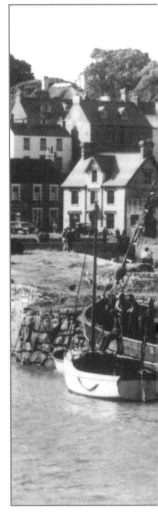

▲ Saundersfoot Harbour c1965 S64243

A trawler and its tender are moored by the harbour wall.

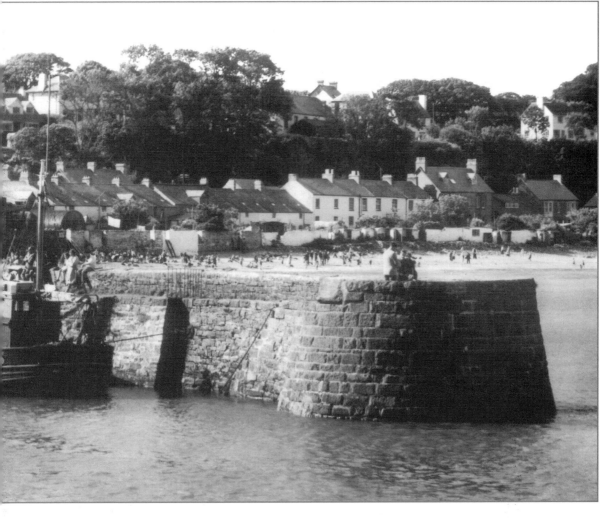

◀ **Amroth
Village c1965** A187038
Lying five miles from Tenby,
Amroth has a pebble shore
but sand is revealed at low
tide. A former mining
village, it wages a
continuous battle with
stormy seas.

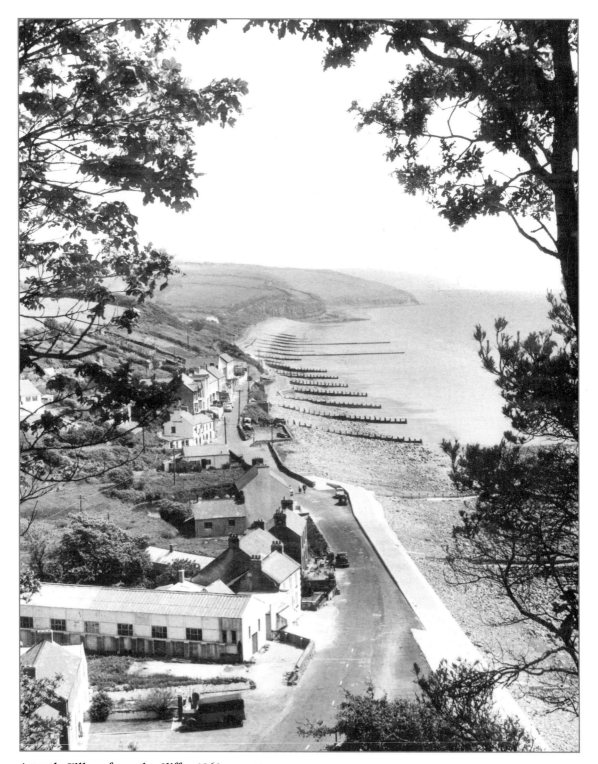

Amroth, Village from the Cliffs c1960 A187046
This is an excellent view showing the protective measures taken to try and prevent the road (and houses!) being washed away by the more ferocious storms. This area was a hunting ground for the earliest settlers.

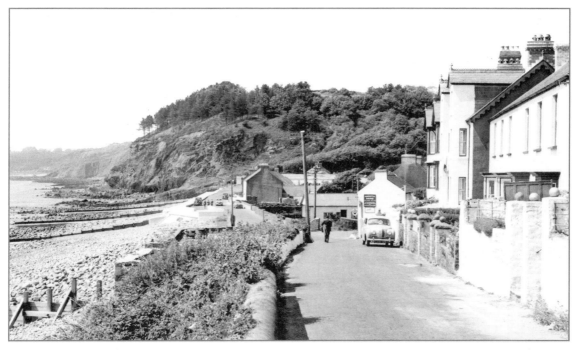

Amroth, Beach c1960 A187048
At very low tide submerged tree stumps, thought to date from c5,000 BC, were seen here. Fossilized hazelnuts have also been found here. The Amroth Arms is on the right.

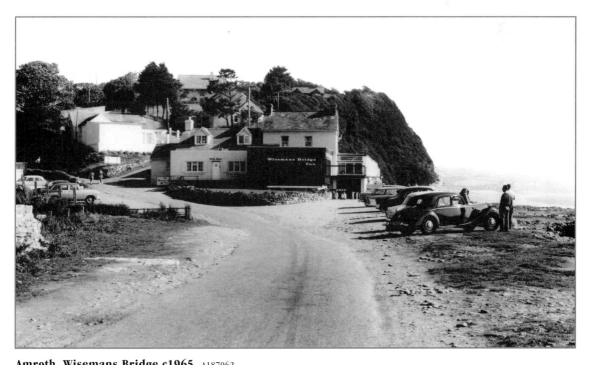

Amroth, Wisemans Bridge c1965 A187062
The bridge is named after Andrew Wiseman, who held land here in 1324. The area was made famous as the setting for Normandy invasion rehearsals in 1943, with Winston Churchill as spectator.

Narberth, Commercial Corner c1955 N115002
Ten miles due east of Haverfordwest, Narberth was once a significant commercial centre. A tollgate was erected here but was destroyed during the Rebecca Riots in 1842-3.

Narberth, Market Square c1955 N115013
Narberth was once a place of great significance, being the residence of Pwyll, the 'Lord of Days'. It is perhaps fitting to end our account with this excerpt from the Mabinogion:
"Pwyll, prince of Dyfed, was lord of the seven Cantrevs of Dyfed; and once upon a time he was at Narberth, his chief palace, and he was minded to go and hunt."

Index

BIBLIOGRAPHY

A History of Haverfordwest, Ed. Dillwyn Miles, pub. Gomer 1999
A Pembrokeshire Anthology, Dillwyn Miles, pub. Gwasg Dinefwr Press 1983
Newport Pem and Fishguard, Michale Lewis, pub. Chalford 1996
Pembrokeshire, Brian John, pub. David & Charles 1976
Pembrokeshire Churches, Michael Fitzgerald, pub. Rosedale 1989
Pembrokeshire Islands, David Saunders, pub. Lily Publications 2000
St David's Cathedral, pub. Pitkin
The Companion Guide to South Wales, Peter Howell and Elizabeth Beazley, pub. Collins 1977
The Description of Pembrokeshire, George Owen of Henllys (ed. Dillwyn Miles), pub. Gomer Press 1994
The Shell Guide to Wales, Wynford Vaughan-Thoams and Alun Llewellyn, pub. Michael Joseph 1969

Frith Book Co Titles

www.francisfrith.co.uk

The Frith Book Company publishes over 100 new titles each year. A selection of those currently available are listed below. For latest catalogue please contact Frith Book Co.

Town Books 96 pages, approx 100 photos. County and Themed Books 128 pages, approx 150 photos (unless specified). All titles hardback laminated case and jacket except those indicated pb (paperback)

		
Amersham, Chesham & Rickmansworth (pb)	1-85937-340-2	£9.99
Ancient Monuments & Stone Circles	1-85937-143-4	£17.99
Aylesbury (pb)	1-85937-227-9	£9.99
Bakewell	1-85937-113-2	£12.99
Barnstaple (pb)	1-85937-300-3	£9.99
Bath (pb)	1-85937419-0	£9.99
Bedford (pb)	1-85937-205-8	£9.99
Berkshire (pb)	1-85937-191-4	£9.99
Berkshire Churches	1-85937-170-1	£17.99
Blackpool (pb)	1-85937-382-8	£9.99
Bognor Regis (pb)	1-85937-431-x	£9.99
Bournemouth	1-85937-067-5	£12.99
Bradford (pb)	1-85937-204-x	£9.99
Brighton & Hove(pb)	1-85937-192-2	£8.99
Bristol (pb)	1-85937-264-3	£9.99
British Life A Century Ago (pb)	1-85937-213-9	£9.99
Buckinghamshire (pb)	1-85937-200-7	£9.99
Camberley (pb)	1-85937-222-8	£9.99
Cambridge (pb)	1-85937-422-0	£9.99
Cambridgeshire (pb)	1-85937-420-4	£9.99
Canals & Waterways (pb)	1-85937-291-0	£9.99
Canterbury Cathedral (pb)	1-85937-179-5	£9.99
Cardiff (pb)	1-85937-093-4	£9.99
Carmarthenshire	1-85937-216-3	£14.99
Chelmsford (pb)	1-85937-310-0	£9.99
Cheltenham (pb)	1-85937-095-0	£9.99
Cheshire (pb)	1-85937-271-6	£9.99
Chester	1-85937-090-x	£12.99
Chesterfield	1-85937-378-x	£9.99
Chichester (pb)	1-85937-228-7	£9.99
Colchester (pb)	1-85937-188-4	£8.99
Cornish Coast	1-85937-163-9	£14.99
Cornwall (pb)	1-85937-229-5	£9.99
Cornwall Living Memories	1-85937-248-1	£14.99
Cotswolds (pb)	1-85937-230-9	£9.99
Cotswolds Living Memories	1-85937-255-4	£14.99
County Durham	1-85937-123-x	£14.99
Croydon Living Memories	1-85937-162-0	£9.99
Cumbria	1-85937-101-9	£14.99
Dartmoor	1-85937-145-0	£14.99
Derby (pb)	1-85937-367-4	£9.99
Derbyshire (pb)	1-85937-196-5	£9.99
Devon (pb)	1-85937-297-x	£9.99
Dorset (pb)	1-85937-269-4	£9.99
Dorset Churches	1-85937-172-8	£17.99
Dorset Coast (pb)	1-85937-299-6	£9.99
Dorset Living Memories	1-85937-210-4	£14.99
Down the Severn	1-85937-118-3	£14.99
Down the Thames (pb)	1-85937-278-3	£9.99
Down the Trent	1-85937-311-9	£14.99
Dublin (pb)	1-85937-231-7	£9.99
East Anglia (pb)	1-85937-265-1	£9.99
East London	1-85937-080-2	£14.99
East Sussex	1-85937-130-2	£14.99
Eastbourne	1-85937-061-6	£12.99
Edinburgh (pb)	1-85937-193-0	£8.99
England in the 1880s	1-85937-331-3	£17.99
English Castles (pb)	1-85937-434-4	£9.99
English Country Houses	1-85937-161-2	£17.99
Essex (pb)	1-85937-270-8	£9.99
Exeter	1-85937-126-4	£12.99
Exmoor	1-85937-132-9	£14.99
Falmouth	1-85937-066-7	£12.99
Folkestone (pb)	1-85937-124-8	£9.99
Glasgow (pb)	1-85937-190-6	£9.99
Gloucestershire	1-85937-102-7	£14.99
Great Yarmouth (pb)	1-85937-426-3	£9.99
Greater Manchester (pb)	1-85937-266-x	£9.99
Guildford (pb)	1-85937-410-7	£9.99
Hampshire (pb)	1-85937-279-1	£9.99
Hampshire Churches (pb)	1-85937-207-4	£9.99
Harrogate	1-85937-423-9	£9.99
Hastings & Bexhill (pb)	1-85937-131-0	£9.99
Heart of Lancashire (pb)	1-85937-197-3	£9.99
Helston (pb)	1-85937-214-7	£9.99
Hereford (pb)	1-85937-175-2	£9.99
Herefordshire	1-85937-174-4	£14.99
Hertfordshire (pb)	1-85937-247-3	£9.99
Horsham (pb)	1-85937-432-8	£9.99
Humberside	1-85937-215-5	£14.99
Hythe, Romney Marsh & Ashford	1-85937-256-2	£9.99

Available from your local bookshop or from the publisher

Frith Book Co Titles (continued)

Title	ISBN	Price	Title	ISBN	Price
Ipswich (pb)	1-85937-424-7	£9.99	St Ives (pb)	1-85937415-8	£9.99
Ireland (pb)	1-85937-181-7	£9.99	Scotland (pb)	1-85937-182-5	£9.99
Isle of Man (pb)	1-85937-268-6	£9.99	Scottish Castles (pb)	1-85937-323-2	£9.99
Isles of Scilly	1-85937-136-1	£14.99	Sevenoaks & Tunbridge	1-85937-057-8	£12.99
Isle of Wight (pb)	1-85937-429-8	£9.99	Sheffield, South Yorks (pb)	1-85937-267-8	£9.99
Isle of Wight Living Memories	1-85937-304-6	£14.99	Shrewsbury (pb)	1-85937-325-9	£9.99
Kent (pb)	1-85937-189-2	£9.99	Shropshire (pb)	1-85937-326-7	£9.99
Kent Living Memories	1-85937-125-6	£14.99	Somerset	1-85937-153-1	£14.99
Lake District (pb)	1-85937-275-9	£9.99	South Devon Coast	1-85937-107-8	£14.99
Lancaster, Morecambe & Heysham (pb)	1-85937-233-3	£9.99	South Devon Living Memories	1-85937-168-x	£14.99
Leeds (pb)	1-85937-202-3	£9.99	South Hams	1-85937-220-1	£14.99
Leicester	1-85937-073-x	£12.99	Southampton (pb)	1-85937-427-1	£9.99
Leicestershire (pb)	1-85937-185-x	£9.99	Southport (pb)	1-85937-425-5	£9.99
Lincolnshire (pb)	1-85937-433-6	£9.99	Staffordshire	1-85937-047-0	£12.99
Liverpool & Merseyside (pb)	1-85937-234-1	£9.99	Stratford upon Avon	1-85937-098-5	£12.99
London (pb)	1-85937-183-3	£9.99	Suffolk (pb)	1-85937-221-x	£9.99
Ludlow (pb)	1-85937-176-0	£9.99	Suffolk Coast	1-85937-259-7	£14.99
Luton (pb)	1-85937-235-x	£9.99	Surrey (pb)	1-85937-240-6	£9.99
Maidstone	1-85937-056-x	£14.99	Sussex (pb)	1-85937-184-1	£9.99
Manchester (pb)	1-85937-198-1	£9.99	Swansea (pb)	1-85937-167-1	£9.99
Middlesex	1-85937-158-2	£14.99	Tees Valley & Cleveland	1-85937-211-2	£14.99
New Forest	1-85937-128-0	£14.99	Thanet (pb)	1-85937-116-7	£9.99
Newark (pb)	1-85937-366-6	£9.99	Tiverton (pb)	1-85937-178-7	£9.99
Newport, Wales (pb)	1-85937-258-9	£9.99	Torbay	1-85937-063-2	£12.99
Newquay (pb)	1-85937-421-2	£9.99	Truro	1-85937-147-7	£12.99
Norfolk (pb)	1-85937-195-7	£9.99	Victorian and Edwardian Cornwall	1-85937-252-x	£14.99
Norfolk Living Memories	1-85937-217-1	£14.99	Victorian & Edwardian Devon	1-85937-253-8	£14.99
Northamptonshire	1-85937-150-7	£14.99	Victorian & Edwardian Kent	1-85937-149-3	£14.99
Northumberland Tyne & Wear (pb)	1-85937-281-3	£9.99	Vic & Ed Maritime Album	1-85937-144-2	£17.99
North Devon Coast	1-85937-146-9	£14.99	Victorian and Edwardian Sussex	1-85937-157-4	£14.99
North Devon Living Memories	1-85937-261-9	£14.99	Victorian & Edwardian Yorkshire	1-85937-154-x	£14.99
North London	1-85937-206-6	£14.99	Victorian Seaside	1-85937-159-0	£17.99
North Wales (pb)	1-85937-298-8	£9.99	Villages of Devon (pb)	1-85937-293-7	£9.99
North Yorkshire (pb)	1-85937-236-8	£9.99	Villages of Kent (pb)	1-85937-294-5	£9.99
Norwich (pb)	1-85937-194-9	£8.99	Villages of Sussex (pb)	1-85937-295-3	£9.99
Nottingham (pb)	1-85937-324-0	£9.99	Warwickshire (pb)	1-85937-203-1	£9.99
Nottinghamshire (pb)	1-85937-187-6	£9.99	Welsh Castles (pb)	1-85937-322-4	£9.99
Oxford (pb)	1-85937-411-5	£9.99	West Midlands (pb)	1-85937-289-9	£9.99
Oxfordshire (pb)	1-85937-430-1	£9.99	West Sussex	1-85937-148-5	£14.99
Peak District (pb)	1-85937-280-5	£9.99	West Yorkshire (pb)	1-85937-201-5	£9.99
Penzance	1-85937-069-1	£12.99	Weymouth (pb)	1-85937-209-0	£9.99
Peterborough (pb)	1-85937-219-8	£9.99	Wiltshire (pb)	1-85937-277-5	£9.99
Piers	1-85937-237-6	£17.99	Wiltshire Churches (pb)	1-85937-171-x	£9.99
Plymouth	1-85937-119-1	£12.99	Wiltshire Living Memories	1-85937-245-7	£14.99
Poole & Sandbanks (pb)	1-85937-251-1	£9.99	Winchester (pb)	1-85937-428-x	£9.99
Preston (pb)	1-85937-212-0	£9.99	Windmills & Watermills	1-85937-242-2	£17.99
Reading (pb)	1-85937-238-4	£9.99	Worcester (pb)	1-85937-165-5	£9.99
Romford (pb)	1-85937-319-4	£9.99	Worcestershire	1-85937-152-3	£14.99
Salisbury (pb)	1-85937-239-2	£9.99	York (pb)	1-85937-199-x	£9.99
Scarborough (pb)	1-85937-379-8	£9.99	Yorkshire (pb)	1-85937-186-8	£9.99
St Albans (pb)	1-85937-341-0	£9.99	Yorkshire Living Memories	1-85937-166-3	£14.99

See Frith books on the internet www.francisfrith.co.uk

FRITH PRODUCTS & SERVICES

Francis Frith would doubtless be pleased to know that the pioneering publishing venture he started in 1860 still continues today. A hundred and forty years later, The Francis Frith Collection continues in the same innovative tradition and is now one of the foremost publishers of vintage photographs in the world. Some of the current activities include:

Interior Decoration

Today Frith's photographs can be seen framed and as giant wall murals in thousands of pubs, restaurants, hotels, banks, retail stores and other public buildings throughout the country. In every case they enhance the unique local atmosphere of the places they depict and provide reminders of gentler days in an increasingly busy and frenetic world.

Product Promotions

Frith products are used by many major companies to promote the sales of their own products or to reinforce their own history and heritage. Frith promotions have been used by Hovis bread, Courage beers, Scots Porage Oats, Colman's mustard, Cadbury's foods, Mellow Birds coffee, Dunhill pipe tobacco, Guinness, and Bulmer's Cider.

Genealogy and Family History

As the interest in family history and roots grows world-wide, more and more people are turning to Frith's photographs of Great Britain for images of the towns, villages and streets where their ancestors lived; and, of course, photographs of the churches and chapels where their ancestors were christened, married and buried are an essential part of every genealogy tree and family album.

Frith Products

All Frith photographs are available Framed or just as Mounted Prints and Posters (size 23 x 16 inches). These may be ordered from the address below. From time to time other products - Address Books, Calendars, Table Mats, etc - are available.

The Internet

Already twenty thousand Frith photographs can be viewed and purchased on the internet through the Frith websites and a myriad of partner sites.

For more detailed information on Frith companies and products, look at these sites:

www.francisfrith.co.uk
www.francisfrith.com
(for North American visitors)

See the complete list of Frith Books at:
www.francisfrith.co.uk
This web site is regularly updated with the latest list of publications from the Frith Book Company. If you wish to buy books relating to another part of the country that your local bookshop does not stock, you may purchase on-line.

For further information, trade, or author enquiries please contact us at the address below:
The Francis Frith Collection, Frith's Barn, Teffont, Salisbury, Wiltshire, England SP3 5QP.
Tel: +44 (0)1722 716 376 Fax: +44 (0)1722 716 881 Email: sales@francisfrith.co.uk

See Frith books on the internet www.francisfrith.co.uk

TO RECEIVE YOUR FREE MOUNTED PRINT

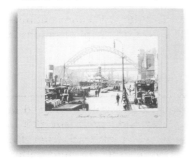

Mounted Print
Overall size 14 x 11 inches

Cut out this Voucher and return it with your remittance for £1.95 to cover postage and handling, to UK addresses. For overseas addresses please include £4.00 post and handling. Choose any photograph included in this book. Your SEPIA print will be A4 in size, and mounted in a cream mount with burgundy rule line, overall size 14 x 11 inches.

Order additional Mounted Prints at HALF PRICE (only £7.49 each*)

If there are further pictures you would like to order, possibly as gifts for friends and family, purchase them at half price (no additional postage and handling required).

Have your Mounted Prints framed*

For an additional £14.95 per print you can have your chosen Mounted Print framed in an elegant polished wood and gilt moulding, overall size 16 x 13 inches (no additional postage and handling required).

*** IMPORTANT!**
These special prices are only available if ordered using the original voucher on this page (no copies permitted) and at the same time as your free Mounted Print, for delivery to the same address

Frith Collectors' Guild

From time to time we publish a magazine of news and stories about Frith photographs and further special offers of Frith products. If you would like 12 months FREE membership, please return this form.

Send completed forms to:
The Francis Frith Collection, Frith's Barn, Teffont, Salisbury, Wiltshire SP3 5QP

Voucher for **FREE** and Reduced Price Frith Prints

Picture no.	Page number	Qty	Mounted @ £7.49	Framed + £14.95	Total Cost
		1	**Free of charge***	£	£
			£7.49	£	£
			£7.49	£	£
			£7.49	£	£
			£7.49	£	£
			£7.49	£	£

Please allow 28 days for delivery	*** Post & handling**	**£1.95**
Book Title	**Total Order Cost**	**£**

Please do not photocopy this voucher. Only the original is valid, so please cut it out and return it to us.

I enclose a cheque / postal order for £
made payable to 'The Francis Frith Collection'
OR please debit my Mastercard / Visa / Switch / Amex card
(credit cards please on all overseas orders)

Number .

Issue No(Switch only)Valid from (Amex/Switch)

Expires Signature

Name Mr/Mrs/Ms .

Address .

. .

. Postcode

Daytime Tel No . Valid to 31/12/02

The Francis Frith Collectors' Guild

Please enrol me as a member for 12 months free of charge.

Name Mr/Mrs/Ms .

Address .

. .

. Postcode

Would you like to find out more about Francis Frith?

We have recently recruited some entertaining speakers who are happy to visit local groups, clubs and societies to give an illustrated talk documenting Frith's travels and photographs. If you are a member of such a group and are interested in hosting a presentation, we would love to hear from you.

Our speakers bring with them a small selection of our local town and county books, together with sample prints. They are happy to take orders. A small proportion of the order value is donated to the group who have hosted the presentation. The talks are therefore an excellent way of fundraising for small groups and societies.

Can you help us with information about any of the Frith photographs in this book?

We are gradually compiling an historical record for each of the photographs in the Frith archive. It is always fascinating to find out the names of the people shown in the pictures, as well as insights into the shops, buildings and other features depicted.

If you recognize anyone in the photographs in this book, or if you have information not already included in the author's caption, do let us know. We would love to hear from you, and will try to publish it in future books or articles.

Our production team

Frith books are produced by a small dedicated team at offices in the converted Grade II listed 18th-century barn at Teffont near Salisbury, illustrated above. Most have worked with the Frith Collection for many years. All have in common one quality: they have a passion for the Frith Collection. The team is constantly expanding, but currently includes:

Jason Buck, John Buck, Douglas Burns, Heather Crisp, Isobel Hall, Rob Hames, Hazel Heaton, Peter Horne, James Kinnear, Tina Leary, Hannah Marsh, Eliza Sackett, Terence Sackett, Sandra Sanger, Shelley Tolcher, Susanna Walker, Clive Wathen and Jenny Wathen.

Free Print – see overleaf